Heritage of the Brush

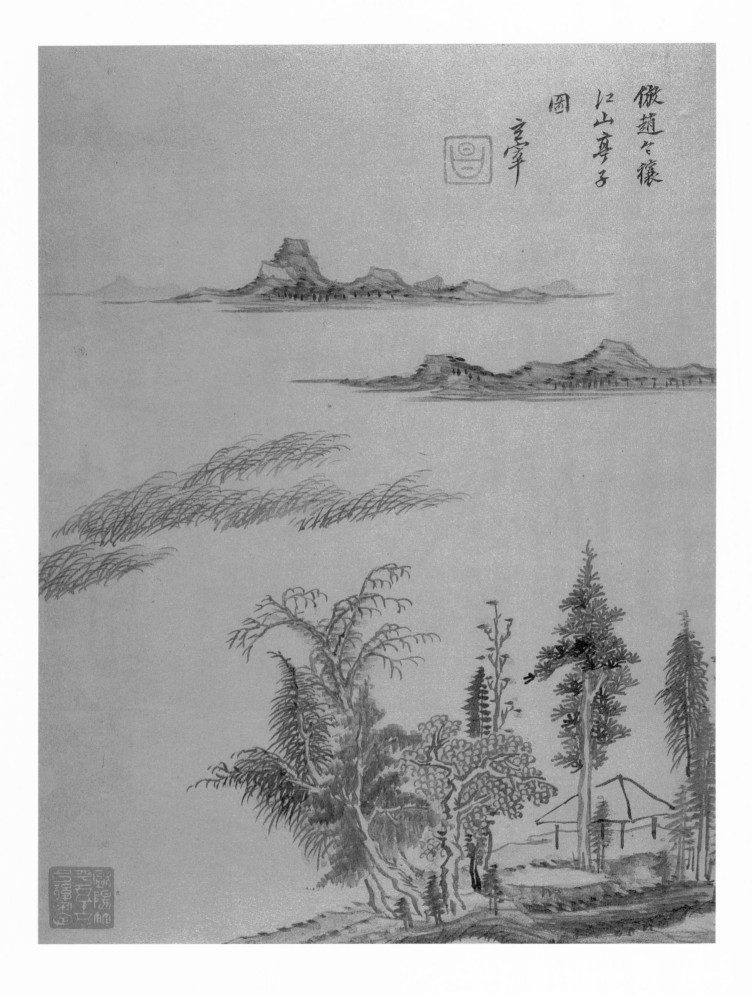

Heritage of the Brush

THE ROY AND MARILYN PAPP
COLLECTION OF CHINESE PAINTING

PHOENIX ART MUSEUM

Published by the Phoenix Art Museum
1625 N. Central Avenue Phoenix AZ 85004-1685

Exhibition Sponsors: Bud Jacobson, Bob and Nancy
Swanson, Conley and Bernadette Wolfswinkel

Cover: Wang Hui, *Southern Inspection Tour:
Benniu Zhen to Changzhou on the Grand Canal* [18]

Frontispiece: Dong Qichang, *Album of Calligraphy
and Landscapes after Old Masters* [5], Leaf C,
'Landscape with Pavilion'

Photography: Craig Smith

Additional photography: cover, [18] courtesy of
Christie's NY [1] Vermillion Photographic

Design: Thomas Detrie

Production Assistant: Cindy Phillips

Composition: Typography Unlimited, Inc.

Lithography: Prisma Graphic Corp.

Library of Congress Cataloging-in-Publication Data

Heritage of the Brush
The Roy and Marilyn Papp Collection of Chinese Painting.
Bibliography: p.
Includes index.
ISBN 0-910407-22-3
1. Painting, Chinese — Ming Ch'ing dynasties, 1368–
1912 — Exhibitions. 2. Papp, Roy — Art collections —
Exhibitions. 3. Papp, Marilyn — Art collections —
Exhibitions. 4. Painting — Private collections — Arizona
— Exhibitions. I Papp, Roy. II Papp, Marilyn. III
Phoenix Art Museum.
ND 1043.5.H47 1989 759.951'074'019173–dc 19 89-42585

Contents

Preface

As the Western states have drawn closer to their Pacific Rim neighbors through trade relations during the past decade, Asian cultural traditions have come to attract more and more attention in the region. Playing a central role in this process here in Arizona, the Phoenix Art Museum has sought to strengthen its collections and exhibitions program in Asian Art and to complement the humanistic study of Asia at the state's major research universities, Arizona State University and the University of Arizona. In support of this goal, Roy and Marilyn Papp together with other museum supporters helped to found the Phoenix Art Museum's Asian Arts Council. As have so many others, Roy and Marilyn have lent generously over the years from their own collection to enhance the presentation of Chinese painting in the Museum's Asian Gallery. Several works from their collection were included in the 1985 exhibition, *The Elegant Brush: Chinese Painting Under the Qianlong Emperor, 1735-1795*. Now we are pleased to hold a special exhibition of works drawn exclusively from Roy and Marilyn's collection of Ming and Qing dynasty paintings, and I would like to take this opportunity to thank them for being such cooperative collectors. We are grateful as well to several friends of the museum, Bud Jacobson, Bob and Nancy Swanson, and Conley and Bernadette Wolfswinkel, who have sponsored this special exhibition, *Heritage of the Brush: The Roy and Marilyn Papp Collection of Chinese Painting*, 18 March - 28 May.

The study and collecting of Chinese painting in the United States has been dominated by a perception forged during the heyday of the Avant Garde, a perception which favored the new, the innovative, and often the eccentric in art. Recognizing a need to preserve, defend, and understand the mainstream traditions in Chinese painting, Roy and Marilyn Papp have gathered works from the fifteenth through the nineteenth centuries which reflect the consolidation of a painting heritage. The result is a collection which brings the viewer to understand better the transmission of traditional styles from master to pupil and the revival of styles of the old masters.

The Museum is grateful to many who collaborated with Claudia Brown, our Curator of Asian Art, to bring this exhibition and catalog to fruition. To Arizona State University professors Ju-hsi Chou, who contributed the introductory essay, and Donald Rabiner, who edited the manuscript, many thanks are due. Jane Wai-yee Leong, graduate student in art history at Arizona State University, translated inscriptions and assisted with the research. Wai-fong Anita Siu, a former ASU graduate student now at Princeton University, provided translations and preliminary research. Ju-hsi Chou contributed the catalog entries on Lan Ying and his followers; Jane Leong wrote that on Dai Xi. The bulk of the catalog entries are the work of Claudia Brown. A special thanks to Professor Howard Rogers of Sophia University, Tokyo, for providing information on several of the works included.

James K. Ballinger, *Director*

Artists in the Exhibition

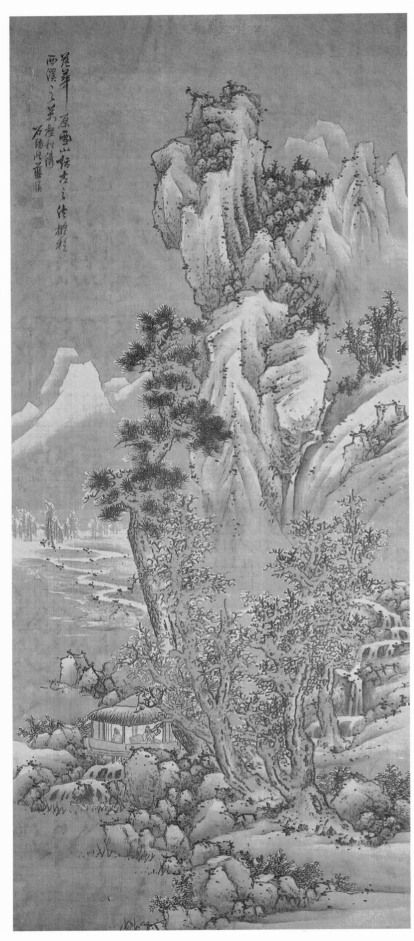

THROUGH THE DISCIPLES' EYES

Transmission of Art and Group Interactions in the Ming and Qing Periods

Ju-hsi Chou

In the Roy and Marilyn Papp collection of Chinese painting we find in several instances the works of both the master and his disciple or disciples. The pairings are not fortuitous, for the collectors have made a conscious effort to acquire such works in order to reveal the specific nature of the transmission of artistic outlook and style. Thus we find the co-presence of Yuan Jiang (active 1680-1740) [23] and his nephew or son Yuan Yao (active 1720-80) [29]; works of Lan Ying (1585-1664?) [8] and his descendants — his son Lan Meng [20], his grandson Lan Tao [22] and, somewhat uncertain in the lineage though undoubtedly a younger clansman, Lan Hui [25]; and a work by Li Ying [16], a painter only tersely recorded, who emulated the early Qing master, Gong Xian (1599-1689) [15] so successfully that the velvety tone and the crisp dotting and brushstrokes recall the master at every turn.[1]

My own interest in these pairings began long ago with methodological considerations in the study of Chinese painting, particularly in dealing with works of uncertain authorship or spurious origin. It is known for instance that on occasion a follower or disciple either volunteered or was pressed into service to ghost-paint for the master. Well-attested is the case of Jin Nong (1687-1764) who, according to a contemporary, so craved extra cash that he was unrelenting in putting to work his disciples Luo Ping (1733-99) and Xiang Jun (active second half eighteenth century).[2] There is evidence as well that Shen Shichong [12] ghost-painted for Dong Qichang [5].[3] Inevitably, under such circumstances, determination of authorship — whether a given work attributed to the master may in fact have been done by one of his disciples — is controversial, although rigorous and controlled comparison can shed light. Careful stylistic analysis makes it possible to pin-point the so-called Jin Nongs that are probably done by Luo Ping, or Dong Qichangs by Shen Shichong, just as among the so-called Lan Yings some probably can be shown to have been painted by his followers, both Chinese and Japanese.[4]

Beyond the realm of ghost-paintings are works of spurious origin, done years or even centuries later by those who were only remotely or not at all connected with the master. On a number of occasions, styles alien to the attributed master have been introduced. Such co-mingling of styles and variations in hands and in quality create chaos in Chinese painting scholarship, where agreement on attribution is rare, regardless of signature, seals and inscriptions. We have here an organic situation: a given attribution is based on a general conception of an artist's style, but the formulation of that overview is itself based upon individual attributions.

Given therefore a 'raw' corpus of a master, it is not enough to conduct internal comparisons or sorting out within the corpus. Unless a set of reliable controls is present, such internal comparisons tend to muddy the waters. The early and late styles of the master may mistakenly be attributed to different hands. Alien and later elements may be seen as 'anticipatory' in nature. Works of lesser quality, done by the master under stress or while ill, may wrongly be cast out as unreliable.

In an article published some years ago, I sought to install such controls first by insisting on a period-by-period, region-by-region discernment of broad, stylistic categories and their changes through time.[5] This has the advantage of screening out works

of later or alien nature. Second, I sought to use disciples' and followers' works as a guide to a given master's style and the quality of his work. The intent was to improve the likelihood of establishing authenticity for a nuclear corpus, from which further attributions could be made or rejected. One key assumption is that due to the profit motive, forgers tend to lose interest along a scale from the well-known to the unknown. While it is lucrative to fake a Wen Zhengming (1470-1559), the profit decreases if Lu Zhi (1496-1576) or Qian Gu (1508 - circa 1578) is the target. It would be further diminished in the third or fourth generation of Wu school followers, such as Hou Mougong (active 1560-1605) and Zhang Fu (1545 - after 1629), to the extent that the likelihood of these artists being forged is considerably lessened.[6] A firm foundation could thus be erected to define, in inverse chronological order, the evolution of a given school. The final unveiling of the master who gave rise to that school is thus made possible. In a network of authentic and authenticated works of the grand and lesser disciples, it is thus possible gradually to converge on a nucleus – Wen Zhengming – inasmuch as it is from him that the rest have derived their styles. He is, it may be argued, the common denominator, whereas they represent the variants and permutations. Fakes, or intruders from without, can be ascertained and, when more is known about the history of Chinese painting, restored to their proper places.

It makes eminent sense then that the usual sequence of inquiry – from early to later – be reversed. Accordingly, I call this approach 'the methodology of reversal.'

The act of transmission itself may offer as much promise as the methodological issue. In the case of Li Ying, it is impossible not to note the unfailing control with which he was able to impersonate Gong Xian. The transmission – in the sense of the Sixth Law of Xie He (active 500-35) – must have been direct. From motif to motif – rocks, trees and huts, as well as the *cun*, dots and brushwork, and even the sudden tremor or decisive turn of a stroke – and from local areas to the overall composition, it is almost as if Li Ying were taking on the *persona* of the older master while leaving little of himself in the painting. This willingness to submit himself, to lose himself in a pictorial configuration of another artist, is in itself a tribute to the other. It is also conveniently held to be at the root of traditionalism in the arts of China, where continuity is more evident than change.

The Li Ying reminds me of an incident some thirty years ago when I was still in Taiwan and learning the techniques of Chinese painting. Our teacher of painting, whom we shall simply identify as the Painting Master, once confided to us that he would not willfully change his style of painting unless and until his own master were to pass away. While the great man was alive, the Painting Master explained, he would refrain from altering the style he was given. A brief survey of his works reveals that he steadfastly adhered to his conviction: the only changes he made were those which paralleled his teacher's.

Some may accuse the Painting Master of being timid. In the twentieth century, when rebels in art are hailed and acclaimed, when individual differences are celebrated, to insist on following one's teacher's way may be anachronistic. But the idea, or ideal, of rebellion is not universally shared. Moreover, the Painting Master neither gave the impression he was *not* going to change, nor did he hold change to be undesirable. For him, it was a matter of timing: he would make the effort at the right moment. Of course, he had better outlive his master, hopefully by a couple of decades, lest his chance of emerging into his own be severely curtailed.

To be sure, there is much that is traditional – traditionally Chinese – in the Painting Master's beliefs. We may sense here echoes of a by-gone era when admiration for a teacher was an act of loyalty, tinged with a touch of genuine gratitude. Let us

not forget that until recently knowledge – and art *is* a form of knowledge – was not open, public property. Its acquisition suggested a privilege received by a stroke of fortune, something to be cherished and never to be taken for granted.

The Hold of Tradition and the Fascination with Change

This story about the Painting Master is real. In relating it, I wish neither to affirm nor to refute his motivation, but only to suggest that he typifies a particular stance within a range of beliefs and attitudes from a past that was still very much alive in mid-twentieth-century China. For this and other reasons, in the traditional model most disciples failed to emerge from under the shadow of their better known and therefore 'recorded' teachers. This was especially true if the latter were major figures in art. Such a scenario calls to mind Sima Qian's acclaim for Confucius:

> A lofty mountain he stands
> For us to look up to him.
> Great deeds he has accomplished,
> For us to emulate him.
> Not able to follow,
> My heart still reaches out to him.[7]

Thus would the Painting Master or a Li Ying gaze with awe upon his illustrious predecessors. Their emulation is in a sense impressed in them by a society that revered teachers but also fortunately neither applauded slavish mimicry nor excluded change as a way of enriching the tradition. Against the Painting Master and Li Ying, there are other far less docile souls, who assimilated and transformed. Some were encouraged by the teacher to do so. One of the more dramatic cases concerns the great Ming master Wen Zhengming (1470-1559) who, while tutored by Shen Zhou (1427-1509), soon set off on his own path through territories beyond the realm of the older master. In his youth Wen had been spurred on by his calligraphy teacher, Li Yingzhen (1431-93), who was highly critical whenever he discovered that the young student had allowed his brush to slip into another's style.[8] Longevity contributed to Wen's artistic domination of Suzhou, but so did his steely, uncompromising character.

During the time that the disciple remains with the teacher, pressure is exerted to assimilate the teacher's full repertory and expressive range. If their talents fail to dovetail, the disciple may limit himself to a range congenial to his temperament by taking on specific subjects and themes. Chen Chun (1484-1544), a disciple of Wen Zhengming, did just that, finding flowers and plants more suited to his freer and more spontaneous nature. Not surprisingly, in posterity these themes became his trademark, against the backdrop of his far more versatile teacher. The outcome was a sub-genre within the Wu school, one which even the patriarch Wen Zhengming grudgingly had to admit came from a source other than himself.[9]

The Schemata and the Transmission of Art

This transmission of art is made simple inasmuch as the pedagogy of Chinese painting involves, on a primary level, the passing on from teacher to disciple of a body of motifs and schemata, together with inherent rhythms and polarities. When the Painting Master taught us, he was but following his own teacher's precedents, providing us with step-by-step instruction in the right method of rendering pine needles, for example, or trees, rocks, figures, huts and pavilions. Once he had ascertained that the

student had made sufficient progress, he brought out his own paintings for the student to copy. The exactitude of the copy was less valued than an ability to produce an effect of pictorial integration. Critiques were informal but specific, noting each flaw and praising successful assignments. Corrections by the master on his disciples' works were frequently made and occasionally are observable.[10] The experienced eye and hand brought focus and force to work which until then had been lacking. We can imagine that this was how Yuan Jiang taught Yuan Yao, or how a Lan Ying or a Wang Hui [18, 19] transmitted his art to descendants and followers. If Gong Xian taught Li Ying at all, his pedagogy could not have been any different. The sketchbooks and notes that the seventeenth-century master left behind in turn inspired the famed *Mustard Seed Garden Manual of Painting* by Wang Gai (active 1680-1705). Its systematic instruction has enabled it to serve amateur painters in China and in Japan for the last three hundred years.

Whether the seventeenth-century version or its twentieth-century counterpart, this pedagogy is the cumulative result of long experience and re-enactment. Earlier approaches may be lacking in range, and they are not as systematic, but the perpetuation of the 'devil-faced *cun*' of Guo Xi (circa 1001-90) from the eleventh century onward, or the persistence of those motifs identified with Huang Gongwang (1269-1354) in the post-Yuan periods could not have come about in any other way. Could one perhaps 'see' again the 'devil-face *cun*' or Huang Gongwang's brushwork in the hills and rocks? Perhaps. But most often, such an act of seeing is predicated on a prior knowledge of the *cun* or the configuration of the brushstrokes involved. The *cun* and brushwork are a given, made to last through the replication of existing originals. To follow in the footsteps of Fan Kuan (circa 960-1030), as Lan Ying found out, requires at a minimum barren and gnarled trees weighted down with age, or low shrubbery on the chilling summit, and angular rock outcroppings [8].[11] When these are present, even the famed raindrop *cun*, the most distinctive feature of Fan's art, can be dispensed with. Through such 'lenses' one may begin to search for rocks and peaks that yield similar configurations, or at any rate to render the objects of one's vision by similar brush configurations. In the Ming and Qing periods, the struggle in art was largely in and with such schemata (*fa*).[12] The mimesis of Nature took second place. In sum, the pedagogy had long been in place and even the Qing sketchbooks and art manuals were but an overdue summation, perhaps brought to a height of systematic clarity via Dong Qichang's insistence on the ritualistic practice of *fang*.[13] Paradoxically, Dong's original intent lay not in the apparently eclectic facade; he sought in the use of these motifs or schemata an opportunity to activate and to unlock the artist's inherent riches. The dynastic change made Dong's idealism obsolete, and the Four Wangs took over the rituals but ignored the cause. What had been stimulus eventually was turned into the substance of imitation.

Early on the disciple is channelled into the pictorial and cultural heritage of his teacher. The act of assimilation is not limited to pictorial schemata, but often broadens to a degree that reflects attitude and beliefs. It stands to reason that each of Lan Ying's followers and disciples should approach the act of painting in much the same way as the master himself did. First, in line with the practice of *fang* which Lan Ying inherited from Dong Qichang, there is a prior determination of the stylistic lineage to which the painting will adhere. (Within the Wulin school, the following old masters were held in high esteem: Li Cheng, Fan Kuan, Huang Gongwang, Zhao Mengfu, Gao Kegong, Ni Zan and Wang Meng.)[14] Then comes the actual process of painting, based on an either intuitive or studied response to the old master's *cun*, motifs, or compositional types. Finally, on completion of the painting comes the writing of the

inscription, clarifying the nature of the initial stimulus. A disciple may also decide to mould the literary and calligraphic contour of the inscription in keeping with his master's: title in clerical script, the rest in the running script, with dedications, and indications of the specific site, year and season.

The premium placed on knowledge and its transmission favors a sustained master-disciple relationship bordering on the filial mode. The saying that 'once a teacher, forever a parent' is not to be taken lightly. (It was Luo Ping who escorted Jin Nong's coffin back to his ancestral district, as the latter lacked a male heir). The disciple comes to hold the teacher's legacy in much the same way that he holds his own familial lineage. He seldom wishes to revolt, save from a perception of his teacher's inadequacy (stemming from a lack of competence or the absence of a literary foundation) or from unsavory behavior or some personality flaw, in which case, in contrast to a family situation, a student could shift his allegiance to other teachers with little difficulty. By and large, hostility was directed elsewhere, against the temptation to 'trust the brush' (xinbi), in automatic, uncontrolled responses; against the lure of fashionable trends of the recent past, especially those of so-called 'heterodox' lineages; and against the unseeming presence of xiqi (the habitual or unthinking) — the desirability of its eradication resulting in a constant refrain that attained the nature of a moral imperative. For wenren artists, since pictorial realization is also self-realization, a program of self-betterment in ethical and spiritual dimensions was instituted, and summed up tersely if not too usefully under conventional headings such as 'travelling ten thousand miles' and 'reading ten thousand volumes' — the purpose of which was to gain experience, vision and insight.[15] This broadly humanistic doctrine makes clear that the emphasis lay not so much in individuality as in perfectability; not in mere difference, but in breadth and depth.[16] Under that assumption, while inadequate teachers often can be replaced, inadequate disciples have only themselves to blame. Talent, motivation and persistence: these are the critical factors,[17] whether in the Ming intuitive model (the sudden dawning of insight), or in the Qing preference for a gradual approach.[18]

We are, in short, confronting a 'program of study' that is far more consuming than meets the eye. For those dedicated to the art of painting, the task could be intense and relentless: assimilation, transformation and synthesis, each step a critical link in a chain leading to artistic maturity. And the synthesis, as even a radical such as Daoji (1642-1707) would admit, comes gradually, not through a facile and willful attempt at change, but only after the fullest degree of assimilation.[19] In his view, the synthesis is what completes the linkage between the known and the unknown. The process is serial and incremental until, by a leap of faith, the artist and the cosmos become one. This oneness of all, which to Daoji is the final consummation of Yihua, or One Stroke, to others, under different names, is the occasion for the birth of a zhiren ('man of attainment'). This is the ultimate goal of the pedagogy, against which the technical aspects of painting are but a point of departure.

Notwithstanding the ideological foundation for the education of a painter in Ming and Qing China, the specific interaction between a master and disciple falls into a different realm of inquiry. Personality factors, leading either to mutual admiration and support or to clashes, are fascinating in themselves. Also relevant are such matters as the time of entry for the disciple, kinship relationships, and mutual support among disciples. The following observations do not take in the full range of these interrelationships, but may be useful in a general way.

Master and Disciple: Relations and Interaction

It is axiomatic that a well-known master may help to ground his students in the basics, and also further their careers through the contacts which his experience and fame make possible. Thus, we cannot consider the art of You Qiu [4] without first noting the ambience provided by Qiu Ying (1494/5 - 1552). The latter, while serving as the source for his art, also provided him with an *entré* to Suzhou society and to patrons at large so that he became easily noticed and accepted into the mainstream.

Many fine painters studied under individuals whose accomplishments ultimately paled beside theirs. Unknown, for instance, are the teachers with whom such eminent artists as Daoji and Zhu Da (1626? - 1705?) took their first lessons. The fact that they did emerge into their own was as much a function of their talent, motivation and persistence, as an indication of the fragile limits of the teachers' art. From an objective viewpoint, while having a major figure as a teacher may be desirable for reasons noted above, it may not always contribute to one's own growth. As an old saying goes, under the shadow of a great tree, siblings can not flourish.

On the other hand, there are some whose talent is so irrepressible that no amount of social pressure or personal admiration for the teacher can rein it in. In the Wu school, for instance, Wen Zhengming broke through the limits of Shen Zhou's art and provided new and expanded vistas for the Suzhou style. Chen Chun in turn stood up to the indomitable Wen and refused to submit to his will. Chen's personality was such that sooner or later, a clash of opposites was sure to take place. Among Qing artists, Wang Hui was introduced to Wang Shimin as a disciple, but the breadth of his art easily broke through the latter's pictorial strictures and gave substance to the idea of 'great synthesis.'[20] Chen Hongshou compelled Lan Ying to admit defeat when his ability to 'sketch from life' so outshone his master's. This is not to say that Chen could fully escape from Lan Ying's influence, which remained considerable for his rendition of landscapes.[21] It may well be that figure-painting served as an escape hatch for Chen Hongshou, for Lan Ying had abandoned the genre after his early, playful years.[22] It is, one might say, the exploration of the weakness of the master that enables the disciple to take the world on his own terms.

These artists were able to establish their personal territory to an extent that they were no longer identified exclusively with the art of their teachers. Such achievement was so extraordinary that one can interpret it only as the result of a phenomenal surge of will power, talent and vision, aided perhaps by singular external circumstances.

Discipleship and the Time of Entry

The time when a disciple begins to learn from his teacher, or when the lives of the two first intersect, can be of critical importance. An early entry, while the master is still on his own quest rather than at its completion, provides a range of opportunities for the disciple. He can either remain with his initial style, change with the master or, taking advantage of the still fragile shell of the master's developing style, break free and venture out on his own. It can be argued that Chen Hongshou benefitted from a still evolving Lan Ying, their age difference being no more than thirteen years. Liu Du, who had been among Lan's earlier disciples, virtually ignored his later style. According to one literary account, while drawing inspiration from either Li Cheng or the Greater and Lesser General Li, he evolved a style rivalling Qiu Ying's in its exquisite refinement.[23] This lattitude may not have been available to later disciples, inasmuch as once the master's own style crystallizes, the act of transmission takes on a fully

stabilized character. By the time Lan Hui found himself under the umbrella of Lan Ying's late style, craggy, dark and somber, he became so deeply entrenched in it that he was no longer able to extract himself.[24]

In the absence of other pictorial or literary data, we may assume that Li Ying knew best the mature style of Gong Xian: his painting, rich in ink tones and full in composition, bears none of the tentativeness of an early, experimental Gong Xian. But if the delicate shell of the early Gong Xian could have been easily broken, Li Ying, who had to contend with Gong Xian in his prime, was constrained to follow closely in the master's footsteps.

Disciples and Kinship

Questions of kinship complicate the picture further. Acquainted with the art of an elderly relation from an early age, and bound by a tradition of familial reverence, the student's will to surpass his elder often diminishes in proportion to his fame and accomplishment. Such instances are numerous: Wen Zhengming and Wen Jia, Chen Chun and Chen Gua (active 1547-53), Chen Hongshou and Chen Zi (1634 - after 1713), Dong Bangda (1699-1769) [26] and Dong Gao (1740-1818), Yuan Jiang and Yuan Yao. The son (or probably nephew in the case of Yuan Yao) played the role not of innovator, but of inheritor, or preserver — a role that the West, given its predisposition toward originality, has deemed of little value.[25] In that capacity the son could extend the longevity of the school, or broaden its base in a way that, within traditional society, assured a high degree of satisfaction.

Yuan Yao provides a case study. He must have been acquainted with the art of his uncle's (or father's) early years. The fact that his surviving corpus reflects only the mature style of Yuan Jiang by no means precludes his knowledge of the elder painter's earlier practice. But by the time he reached his forties, it is likely that the Yuan Jiangs before his eyes would have been later works, post-dating the seemingly uncontrolled fluctuation and experimentation in Yuan Jiang's earlier years. And indeed, the younger Yao himself would never show a predilection for the unpredictable or the untried. In retrospect, it is not unlikely that by this time even the elder Yuan had found his own early phase to be unstable and incoherent and had conveyed his dissatisfaction to the younger man. For in Yuan Yao, one finds a contentment with the known, evincing an even narrower range than the elder's. The palaces and pavilions are intact, and the repertoire continues, but the interaction of parts is less dramatic. The pace and movement take on a measured tempo, devoid of the sharp turns and unexpected twists that in a Yuan Jiang could break loose with abandon.[26]

To reiterate, the stability of an artist like Yuan Yao consists in his acknowledgement of his own role, which is essentially that of an inheritor. An untimely entry and kinship deprived him of the chance to become an innovator. Still, Yuan Yao was no less a virtuoso than his predecessor, although he may have lacked the latter's gusto. His achievement lies in extending the vitality of the school beyond the lifespan of his elder, thus assuring the survival of the school. Despite the encroachment of the so-called Eight Eccentrics, whose scholarly background appealed to the wealthy and powerful of Yangzhou, Yuan Yao maintained a firm foothold in the city while enticing the Shanxi merchant-patrons into his fold.

Disciples need a master, and a master himself can benefit from the best of students who, if he is fortunate, come from the scholarly elite of Chinese society. The case of Dong Qichang is particularly illuminating: a painter of only occasional bursts of brilliance, he nonetheless had a host of followers, including Wang Shimin, Wang Hui and Wang Yuanqi, the sum of whose artistic accomplishments easily surpassed his. One may wonder how his heritage – the concept of the Southern School and the practice of *fang* – would have fared had his ranks of disciples not been what they were. Similarly, the Wulin school would have been even less known had it lacked a Feng Xianti to expand and broaden the *Tuhui Baojian*, thus publicizing the Lan Ying heritage.[27] (Unfortunately, even this failed to reverse the growing infamy of the founding master, who in later years was increasingly linked to the Zhe school.)

The disciples themselves could also form a support group, developing something akin to a fraternal relationship. This occured despite the personality conflicts and petty jealousies common to such a group.[28] Nevertheless, a sense of *esprit de corps* generally prevailed, the disciples bound by a common loyalty to their master. When the sons of the master were talented, the others gravitated around them. Otherwise, seniority, ability, and social prestige were likely to be the criteria by which a real or nominal leader would be chosen. Some of his functions may have been mundane or quasi-filial, such as running errands for the master and his family or aiding fellow disciples in difficult circumstances. Otherwise, the core of the fellowship lay, if not in renewal or revitalization, then in sustaining and expanding the school's influence during and beyond the master's lifetime.

The best testimonials to the interaction of the disciples come of course from the *wenren* painters. Professional painters, like the Yuans and the Lans, seldom leave any written traces. The *wenren* artists, from their literary gatherings, poetic, calligraphic and pictorial exchanges, and their travels and familial interactions, give us a sense of the fellowship that permeated their world. A glance at their surviving letters reveals as well the pragmatic and economic activities which were an important part of the school. Coordinating the fellow-disciples, building up a network of clients, advising patrons on the purchase of antiquities, and even developing other skills and pursuing other interests: these are an integral complex of operations by which the school intensified its impact on the art scene and on the wider society.

Leadership in such endeavors required an entrepreneurial spirit, like that of Wen Peng (1498-1573) in the Wu school. The elder son of Wen Zhengming, and therefore the logical heir to his mantle, Wen Peng was not a painter himself. Unlike the younger son Wen Jia (1501-83), who as a painter was forever in the shadow of the great master, Wen Peng turned to calligraphy and to seal carving, in which he was an acclaimed innovator. Even during Wen Zhengming's lifetime, Wen Peng was already showing his mettle as the entrepreneur of the family, and is likely to have either managed, or assisted in his mother in managing, the family fortune, freeing the old master to spend his time with friends and engage in the refined pursuits of poetry, calligraphy and painting while upholding impeccable moral principles.

While the old master took the high road, Wen Peng the son occasionally chose the low road. An account from outside Suzhou by a rival Yunjian collector, Zhan Jingfeng, painted an unflattering picture of Wen Peng as a forger, operating right under the luminous presence of his august father.[29] For a commission of twenty *jin*, likely twenty taels of silver, Wen was said to have made a tracing copy of Huaisu's *Autobiographical Essay* and attached the original inscriptions to this copy to sell it,

Zhan implied, as an original to those who wished to ingratiate themselves with the then grand secretary, Yan Song (1480-1565). When mildly reproached, Wen Peng was irascible and unrepentant. One of his letters shows that, in terms of his attitude toward the antique, Wen Peng was no better than some dealers today, treating ancient works as commodities to be split up and sold for profit.[30]

But this same Wen Peng must have played a critical role in pulling the Wu school together. He, with Wen Jia, advised the fabulously wealthy Xiang Yuanbian (1525-90) on the acquisition of antiques.[31] More importantly, directly or through his connection to collectors in the region, he could often lend assistance to impoverished members of the Wu school, like Qian Gu.[32] In a number of transactions recorded in letters, Wen Peng assumed a pivotal role, pulling strings, connecting fellow artists with patrons and finding ways to consumate a variety of deals. Indeed, through his entrepreneurial ability and experience, Wen Peng, more than his younger brother, assumed effective leadership of a tightly knit group of disciples in Suzhou that included, among others, such eminent figures as Wen Boren (1502-75), Lu Zhi and Wang Guxiang (1501-68). The jealousy of the Yunjian collectors was but a reflection of Wen Peng's powerful influence during the late Ming. Without him, the Wu school after the demise of its founding master would not have fared so well; under his stewardship, its survival was lengthened even beyond the fall of the dynasty.

NOTES

1 Li Ying is recorded in two sources: *Tuhui Baojian Xuzhuan*, ed. Feng Xianti, (in *Huashi Congshu*, ed. Yu Anlan [Shanghai, 1963]), *juan* 2, 45, where he is described as a Yangzhou native, skilled in landscape, noted for 'deep ink and strong brush;' and *Zhongguo Meishujia Renming Cidian*, ed. Yu Jianhua (Shanghai, 1981), citing additional sources that place Li Ying in Taizhou near Yangzhou prefecture and note his skill as a seal-carver.

2 See Mu Yiqin, 'Jin Nong de Huihua yu Luo Ping de Daibi' (Jin Nong's paintings and Luo Ping's participation), *Mingbao Yuekan* XX/1, (January 1985), 56-58.

3 See James Cahill, *The Distant Mountains* (New York and Tokyo, 1982), 82.

4 See Lan Ying's biography by Hugh Wass and Chaoying Fang in *Dictionary of Ming Biography*, ed. L. Carrington Goodrich and Chaoying Fang (New York and London, 1976), I, 786-88.

5 'The Methodology of Reversal in the Study of Wen Cheng-ming,' *Fung Ping Shan Memorial Volume* (Hong Kong, 1983), 428-37.

6 Zhang Fu's identity remains problematic. Yu Jianhua, 853, mentions three artists of this name. The first appeared far too early in time (1403-90). The latter two, however, may well be the same individual – our Zhang Fu – since both were known to have studied with Qian Gu and both share the same *zi* of Lingshi (though the character *ling* is written differently). See also *Minghua Lu*, *juan* 4, 47 and *Wusheng Shishi*, *juan* 3, 48 (both in the *Huashi Congshu* edition).

7 See Sima Qian, *Shiji*, in *Ershiwu Shi* (Taipei, 1956), II, 774.

8 See Wen Jia's biography appended to Wen Zhengming *Futian Ji* (Taipei, 1968 reprint), II, 895.

9 See Chen Baozhen, *Chen Chun Yanjiu* (Taipei, 1978), 20ff.

10 For an example of a teacher's correction, see *Old Trees by a Wintry Brook*, in *Eight Dynasties of Chinese Painting* (Cleveland Museum of Art, 1980), no. 176. This I consider to be a school piece, signed by Wen Zhengming and bearing evidence of his forceful 'corrections,' mainly in the dark twigs in the trees, versus the far weaker execution elsewhere.

11 Lan Ying himself took pride in being able to perceive the distinction clearly in approaching a variety of pre-existing styles. See *Tuhui Baojian Xuzhuan*, *juan* 2, 14: 'In his middle years, he found his own style, and carefully discerned the differences existing among Song and Yuan masters. He never erred in matters regarding who did what sort of *cun*, wash and lineage, and who did what sort of contour, dots and style. Even now, the late-comers have benefitted from his knowledge....'

12 Art treatises and manuals, and teachers as well, place the emphasis on *fa*. See for example, Daoji's *Hua Yulu* (in *Hualun Congkan*, ed. Yu Anlan, [Beijing, 1962]), ch. 2 ('Understanding *fa*') and ch. 3 ('Transformation').

13 For the cult of *fang*, see my own dissertation, *In Quest of the Primordial Line: The Genesis and Content of Tao-chi's Hua Yu Lu* (Princeton University, 1970); and Cahill, 120-26.

14 A specific example of such transmission within the Wulin school pertains to the mythical 'bone-less' landscape tradition of Zhang Sengyou and Yang Sheng, which resulted in the brilliant contrast among the blue-green hues of the mountains and hills, the vermillion of autumn trees and the white of cloud formations. In the late Ming, Dong Qichang apparently did much to encourage this heritage. Lan Ying worked in the genre on several occasions, including his *Immortals Dwellings in Red Mountains*, published in *Nanju Meiga-en*, (Tokyo, 1907), XVII. For Liu Du and Lan Meng's exposition of the theme, see respectively the cover of *Yiyuan Duoying* XII (1981) and Christie's New York sale, 2 June 1988, lot 33.

15 See Dong Qichang's *Huazhi*, (*Hualun Congkan* edition), I, 80.

16 For a theorist like Daoji some of the difference may be moot; see ch. 3 of his *Hua Yulu*, 147-48.

17 A fascinating account by Qingliang Daoren of Huang Shen's breakthrough after leaving Shangguan Zhou's studio is included in Gu Linwen, *Yangzhou Bajia Shiliao* (Shanghai, 1962), 12-13. Another account by Xie Kun, in *Shuhua Suojian Lu* (*Meishu Congshu* edition), 107, relates that when Huang arrived in Yangzhou, he initially emulated the refined style of Xiao Chen and Han Fan, but finding little reception, decided to break away from their confines and succeeded after three years of intensive effort.

18 Dong Qichang's approach may be termed intuitive and sudden, while his Qing followers tend to favor a gradual progression. Even Daoji in ch. 3 of his *Hua Yulu* describes the evolution of an artist as an essentially gradual process, summarized in the alternation between *fa* ('method') and *bian* ('transformation').

19 Note particularly chapters 3 and 9 of his *Hua Yulu*. The theoretical framework discussed below stems from the *Hua Yulu* and other Ming and Qing writings.

20 For the conflicts between Wang Hui and Wang Shimin, see Jiang Chun, 'Wang Shimin yu Wang Hui de Guanxi' (The Relationship between Wang Shimin and Wang Hui), *Yilin Conglu* (Hong

Kong, 1975), II, 309-13. In addition, Gong Wei, in *Chaolin Bitan* (Beijing, 1984), *juan* 4, 90, related an incident in which a certain Mr Wang from Yushan – probably Wang Hui – caused considerable discomfiture to his teacher.

21 For Chen Hongshou's rendition of Lan Ying-esque trees in *Yang Sheng and Maidens*, likely a pre-1644 work, in the collection of Palace Museum, Beijing, see *Gugong Bowuyuan Cangbao Lu* (Hong Kong, 1985), 44 (left pl.) and 157-58.

22 See *Tuhui Baojian Xuzhuan, juan* 2, 13, and note 27 below.

23 See *Tuhui Baojian Xuzhuan, juan* 2, 27. The author was referring to such genres as 'female figures and spring palaces.' Also see Shen Yiji et al, *Zhejiang Tongzhi* (1735 edition, Taipei reprint, 1967), VI, 3248: 'Having mastered Lan Ying's brush idea, [Liu Du] afterwards further changed his style, to follow in the footsteps of the Greater and Lesser General Li....'

24 See catalog entry 25 below. Contrast the case of Yu Zhiding, who was a mere child when he studied with the aging Lan Ying, but who, in developing the art of portraiture, went beyond the confines of the Wulin school to establish his own fame. Also see Hu Zhi, 'Yu Zhiding Nianpu' (Biography of Yu Zhiding), *Duoyun*, 3 (1982), 206, where in light of the age discrepancy the author questions whether Yu ever studied with Lan.

25 In this context, it may be significant that it took a painter as resourceful as Wang Yuanqi (1642-1715) – and one intervening generation – to remove the enveloping veil his grandfather, Wang Shimin, cast over the entire clan. The death of the patriarch in 1680, when Wang Yuanqi was in his thirties, plus the absence of any major talents in the middle generation of the clan, paved the way for his own liberation. Wang Hui in this instance was above all a rival, not an imposing figure within the inner circle of the Wang clan. As such, his presence stimulated, rather than inhibited, the growth of the younger artist (see Zhang Geng, *Guochao Huazheng Lu* [*Huashi Congshu* edition], *juan* 3, 51). Also, while the Wang clan of Loudong was preeminent in official and scholarly circles, Wang Hui was but a professional painter and therefore an outsider at best.

26 See my discussion in *The Elegant Brush: Chinese Painting under the Qianlong Emperor, 1735-1795* (Phoenix Art Museum, 1985), 117-26.

27 Regarding Feng Xianti's authorship of the expanded, Jielü Caotang edition of *Tuhui Baojian*, see Huang Yongquan, '*Tuhui Baojian* Yuankeben yu "Jielü Caotang" ben Huang Gongwang Zhuan Kaobian,' (The biography of Huang Gongwang in the original edition of *Tuhui Baojian* versus that in the Jielü Caotang

edition of the same title), *Meishu Shilun*, 2 (1985), 75ff. Among Lan Ying's disciples there was a 1640 *jinshi*, Zhou Shichen, whose biography appears in Feng Jinbo, *Guochao Huashi* (Zhonghua Shuju edition), *juan* 1, 5b-6a. A landscape handscroll by Zhou is in the Museum of Fine Arts, Boston.

28 For Feng Xianti's ambivalent characterization of Lan Meng, his master's son, with whom he was of the same generation, see *Tuhui Baojian Xuzhuan, juan* 2, 41: 'Lan Meng... is skilled in depicting landscapes. In emulating the works of the Song and Yuan masters, he is always able to distill their essence. While he is lacking in brushtrength, he nonetheless is noted for a loose and yet crisp rendering of mountains and valleys, like icy pear and snow-white lotus root, which pleases one's palate.'

29 See Zhan Jingfeng, *Zhanshi Xuanlan Bian* (Taipei, 1970 reprint), 30-32.

30 See Bian Yongyu, *Shigutang Shuhua Huikao* (Taipei, 1958), II, 386: '*The Thousand Character Essay* in four scripts is truly excellent. If you were to divide it into four units, each may indeed be worth ten taels (of silver).'

31 *Shigutang Shuhua Huikao*, II, 385ff.

32 See Bian Yongyu, *Shigutang Shuhua Huikao*, II, 387. In a letter to Qian Gu, Wen Peng commanded: 'Here are four album leaves. Please render them in light colors and preferably in the styles of Huang Gongwang and Wang Meng. Do try to get them done today, for I have urgent needs of them.' In another letter of a similar nature, Wen Peng addressed a certain Wufa: 'The price of the painting is one and a half *shi*. With calligraphy the price would be one tael of silver. Since it is of an urgent nature, I would turn them over for your use. Regarding the snowscape, master Ju [Jie] has one ready. It can be borrowed in an emergency.' See Cai Wenbin and Shi Yinchi ed., *Zhonghua Lidai Mingjia Shouzha Moji Daguan* (Taipei, 1978), 279. For help rendered to Qian Gu, see Tao Liang, *Hongdoushu Guan Shuhua Ji* (Taipei, 1972 reprint), I, 155ff.

1 WANG ZHENG (15th century)

Two Immortals

Two-fold screen, ink and light color on silk
Each panel 155.5 × 85.7 cm

Although Wang Zheng is unrecorded, the style of these two panels suggests he was painting during the fifteenth century in the circle of artists at court or working independently in what has been loosely termed the Zhe School of painters. Each panel is signed 'painted by Wang Zheng' with one seal reading *ri jin qing guang* meaning 'daily in the pure luminous presence [of the emperor].' This evidence suggests that Wang was painting at the imperial court. The same legend is found on seals used by the fifteenth century court painters Zhou Wenjing (Mu Yiqin, 232) and Ni Duan (*Gugong Shuhua Lu*, III, 309).

The two panels probably were part of a set of hanging scrolls depicting the eight immortals – similar in style and format to a surviving set of four scrolls representing the eight immortals by Zhang Lu (circa 1464 - circa 1538) (*ZGSHT*, I, 8-003). The present work eventually made its way to Japan where the two hanging scrolls were remounted as a screen of the type often used in Japanese Buddhist temples as a background for ordination ceremonies. Wang's brush mannerism in the bold and tortuous lines of the drapery stands close to that employed by Zhang Lu, but unlike Zhang, Wang reserves this showy stroke for the garments only, complementing it with fine delineation of the facial features and a smooth application of side-brushstrokes, dotting and wash to render the landscape setting. Wang thus provided his patron with works which had the spark of later Zhe School bravura but nevertheless adhered to a conservative ideal of descriptive painting.

 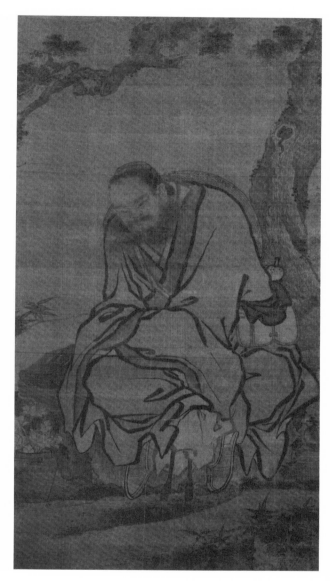

2 ANONYMOUS (Zhe School, 16th century)

Landscape

Hanging scroll, ink and light color on silk
173.5 × 47 cm

The Zhe School preserved and elaborated the descriptive landscape tradition which had begun in the tenth century and by the fourteenth century had evolved into a conservative style which could be adapted to meet current tastes. Standing between the monumentality and drama of the early Zhe School and the elegant reworking of the style by Suzhou artists Zhou Chen and Tang Yin, this anonymous work, bearing neither signature nor artist's seal, presents its mountain scenery within the representational framework of spatial recession and atmospheric depth. Blank silk reads effectively as heavy mist and overlapping rock faces read as lit and shadowed surfaces in the distance.

3 YANG JISHENG (1516-55)

Travelling at Mount Tianhua

Dated 1551
Hanging scroll, ink on paper
147.5 × 39.5 cm

The courage of the Ming official Yang Jisheng in speaking out against ill-advised policies became legendary. In 1551, he memorialized the throne to protest a policy of placating the Mongols who had been raiding the northwestern frontier. Finding his opposition offensive, the Jiajing emperor sentenced him to corporal punishment, followed by prison and eventual exile to a post in distant Gansu province. Later recalled to court, Yang denounced the powerful minister Yan Song for crimes and misuse of office. His accusation rejected by the emperor, Yang this time was nearly fatally beaten and held in prison. When he was sentenced to death, his wife entreated the court to let her take his place on the execution ground. Yang was executed shortly afterwards at the age of thirty-nine.

Honored by later generations for his brave and uncompromising loyalty to the throne, Yang has been little known as a calligrapher and painter. However, scattered records of bamboo and landscape paintings from his hand do exist (Ferguson, 354) and his calligraphy survives in modern collections (see for example Suzuki, A17-116). A rare surviving landscape painting, the present work was executed in 1551, during Yang's period of exile in the northwest. He inscribed the painting with a poem:

> Tianhua is very near to the west of the prefectural city;
> Kingfisher-blue cliffs and cinnabar-red crags, facing them brings on enchantment.
> Towers and pavilions accord with the changing form of the mountains' rise and fall;
> Shadows of banners and pennants flicker up and down the trees.
>
> From an elegant window, official tassels glitter against a clear view of the sky;
> Clouds enter, and one could scoop them along with one's sleeves.
> There is no predicting whether I'll return to this beautiful place again;
> About to leave, I brush past the rocks and waste a new verse.
>
> While travelling at Mount Tianhua on the ninth of the ninth month of the *xinhai* year [1551] in the Jiajing reign period, painted and inscribed by Yang Jisheng. [Artist's seals] Yang Jisheng yin, Shushan.
>
> > [adapted from a translation by Howard Rogers]

The double ninth is the Chongyang festival day, on which it is customary to climb to a high place. Yang, serving in exile in a minor post at Didao, made his climb in the nearby foothills of Mount Tianhua and commemorated the day with this painting. The style, a curious version of the manner of Mi Fu (1051-1107), may derive from the reworking of the Mi style by Suzhou artists like Chen Chun (1483-1544). Since Yang's portrait had been painted shortly before his exile by the Suzhou artist Ju Jie (1527-86) (recorded in *Shiqu Baoji Xubian*, 2004), he may well have had occasion to see paintings from this school.

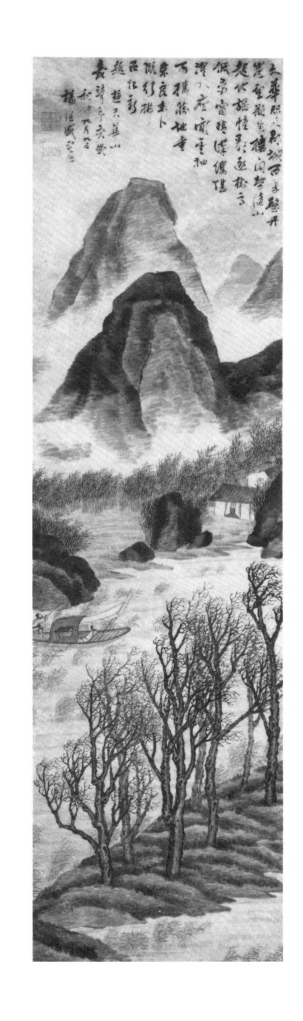

4 YOU QIU (active circa 1540-90)

Lohans Crossing the Sea

Dated 1587
Handscroll, ink on paper
31.2 × 724 cm

Little is recorded of the life of You Qiu. He is said to have studied under Qiu Ying, and to have married Qiu's daughter, also a painter. Though trained in Suchou, he later moved to Taicang near present-day Shanghai. Noted particularly for their fine-lined (*baimiao*) ink drawing, You's surviving works are predominately paintings of literary gatherings and portraits of scholars, but narrative and religious themes figure prominently in his biography. He is said, for example, to have studied the work of the Song painter Liu Songnian, a master of Buddhist subjects, and to have painted a cycle of wall paintings in the Guandi Temple in Taicang.

You Qiu's signature here is characteristically terse:

> Autumn of the *dinghai* year [1587], respectfully painted by You Qiu of Wumen,
> [artist's seal] Qiu.

The frontispiece and colophon are by the connoisseur-calligrapher Deng Erya (1883-1954). Four collectors' seals, including two of Ding Nianxian (twentieth century), appear on the painting. Aside from its signature, then, the scroll bears only recent documentation, but the painting nonetheless fits comfortably into You's ouevre. Among surviving works, which like this one combine a delicate ink-line technique with descriptive, anecdotal detail, many parallels to this scroll can be found. For example, You's hanging scroll of 1573 illustrates a dragon materializing in the clouds (*ZGSHT*, I, 3-029) and provides a precedent for the dragon appearing in clouds in the present scroll.

A significant body of religious paintings dates from the late sixteenth century. Some painters of You's background specialized in Buddhist themes. You's own sister-in-law, another daughter of Qiu Ying, was a noted painter of Buddhist themes, specializing in paintings of Guanyin (*Jade Terrace*, 34). The theme of lohans crossing the sea, which puts these Buddhist 'saints' into a popular religious context of traveling to an immortal realm, was apparently widespread at the time. Wu Bin [7] painted the theme in 1583, four years before the present scroll (see *Style Transformed*, 275-81, no. 043, and Cahill, *Distant Mountains*, 176 and n. 3. A strong similarity in style and motifs to the present scroll strengthens Cahill's argument for dating that painting to 1583 rather than 1643).

While these may not be strictly devotional works, their light-hearted caricatures are not out of keeping with the traditional and respectful rendering of Buddhist and Taoist themes. Some of the figures here reflect conventional iconography, if not stock figural types. The Wu Bin scroll and this one share motifs with each other and with such scrolls as Ding Yunpeng's *Five Hundred Lohan* (*Eight Dynasties*, no. 205).

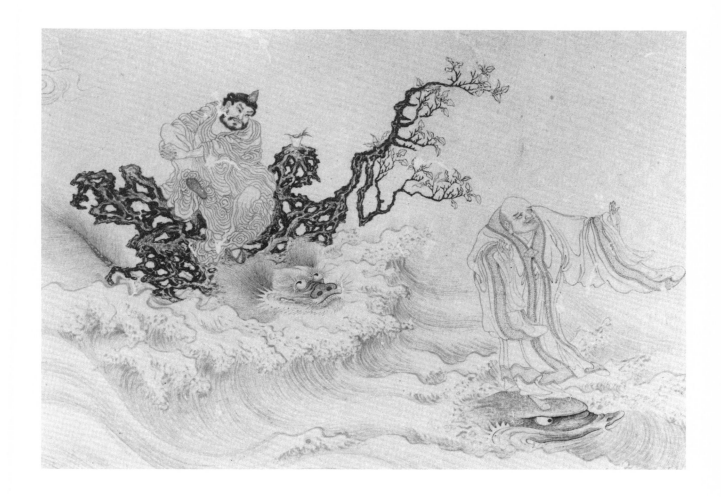

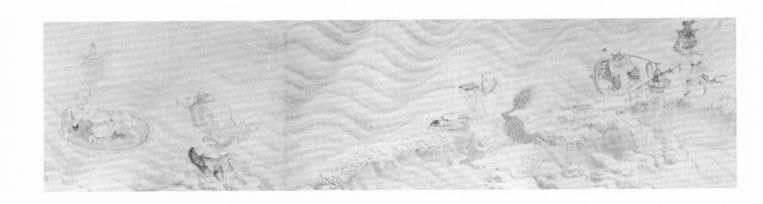

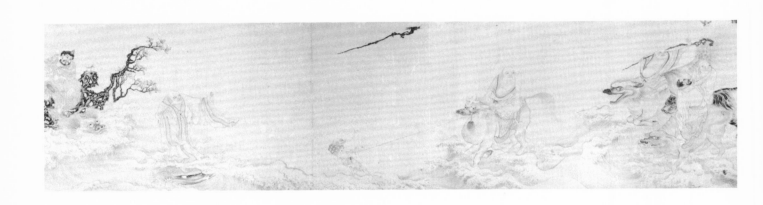

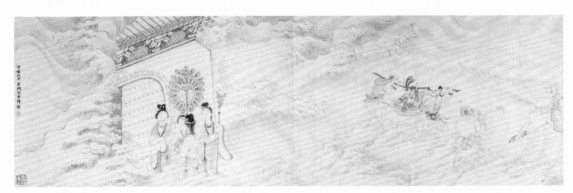

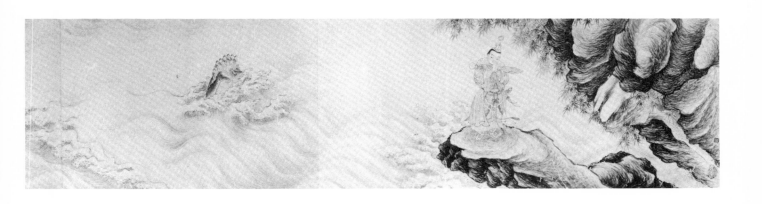

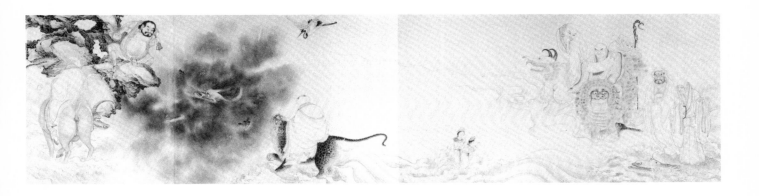

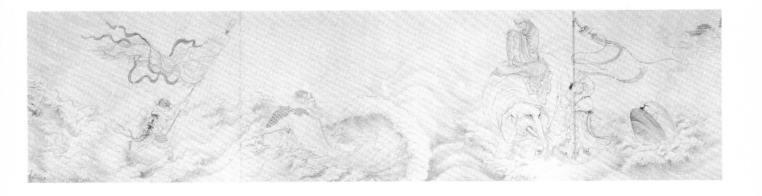

5 DONG QICHANG (1555-1636)

Calligraphy and Landscapes after Old Masters

Album of 16 leaves; calligraphy, ink on silk; paintings, ink or ink and color on gold paper
Each leaf 32 × 23.2 cm

Dong Qichang's life, his art and his theory and criticism have been the subject of several extensive studies. Of humble origins, Dong showed his prodigious talent early and was able to secure first the education and then the civil service degrees that would enable him to rise eventually to become tutor to the heir apparent and later president of the Board of Rites. In connoisseurship, art theory and painting and calligraphy, he came to wield tremendous sway, not only during his lifetime but nearly to the present.

Active in Songjiang, Dong and his circle (see entry 12 on Shen Shichong) created a local style and theory based in part on a reaction against the painting style of their rivals in Suzhou. In his early paintings, Dong analyzed and reworked master-works of the past, and in his middle years he built upon this historical foundation to create structural landscapes of a highly intellectual nature.

Attributable on stylistic grounds to the last fifteen years of Dong's life, this album reflects the artist's fully integrated repertory of landscapes derived from characteristic features of past masters. Far from the artistic quotations of Dong's early years, these works draw loosely upon a vocabulary of conventionalized styles shared by members of Dong's circle. Dated albums, one from 1630 (Suzuki, A17-115, now in the Metropolitan Museum) and another with leaves of various dates (see Kohara, pls. 17-1 through 17-5), confirm that this style evolved during Dong's intermittent involvement at the Beijing and Nanjing courts.

The eight pairs of leaves here have eight counterparts of identical format, medium and dimensions, and similar inscriptions and seals, in the H. C. Weng collection (see Suzuki A13-051). All sixteen leaves clearly were once part of a single work – perhaps forming part of an even larger album. The non-absorbent gold ground for the paintings heightens the fluidity of Dong's confident brushstrokes, reflecting the ease with which the elderly master recalled essential characteristics of works he had seen. Dots and sometimes washes of color enliven the surface of several leaves.

Published: Suzuki, S13-034

Leaf A
After the style of *Spring Mountains* by Zhao Wuxing [Zhao Mengfu]. [Signed] Xuanzai, [artist's seal] Chang.

Leaf B
Imitating the painting method of Beiyuan
[Dong Yuan, active mid tenth century], [signed] Xuanzai, [artist's seal] Chang.

Leaf C
Imitating *Landscape with Pavilion* by Zhao Lingrang, [signed] Xuanzai, [artist's seal] Chang.

Leaf D
Imitating *Autumn Clouds Rising from the Peaks* by Juran [active circa 960-80], [signed] Xuanzai, [artist's seal] Chang.

Leaf E
Leaning against the trees in front of the eaves,
Looking afar to the village on the plain.

[Signed] Xuanzai, [artist's seal] Chang.

Leaf F
After *Cooling Shade among Streams and Mountains*
by Huang Zijiu [Huang Gongwang]. [Signed] Xuanzai, [artist's seal] Chang.

Leaf G
Pines and Streams.
[Signed] Sketched by Xuanzai, [artist's seal] Chang.

Leaf H
The riverbank rises under shadow of foliage.
At the height of the ridge, clouds hover past.

[Signed] Dong Xuanzai, [artist's seal] Chang.

[translation by Jane Wai-yee Leong]

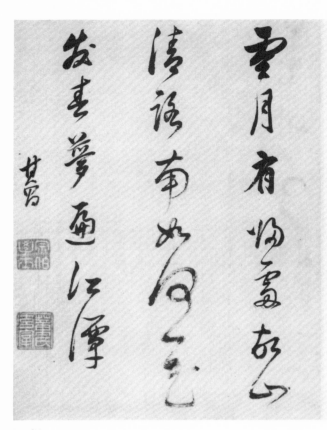

Leaf A

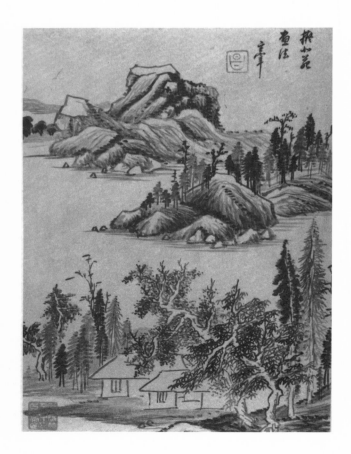

Leaf B

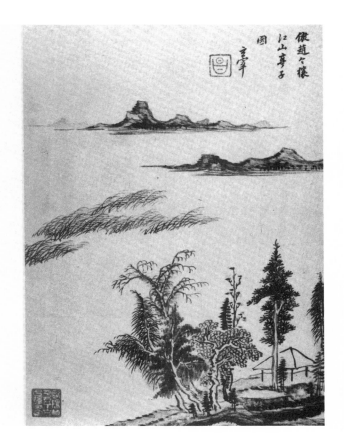

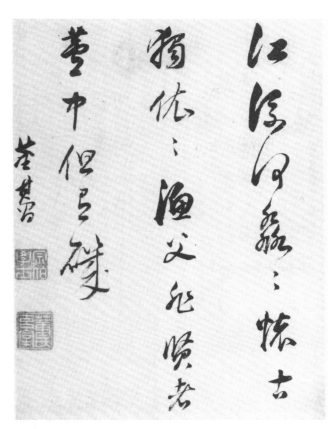

Leaf C

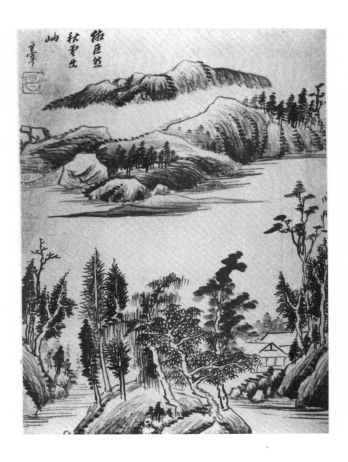

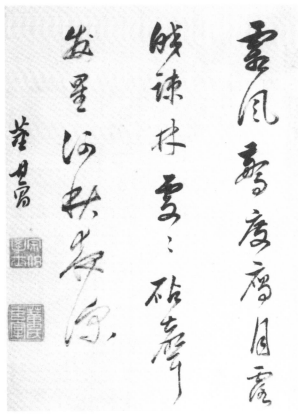

Leaf D

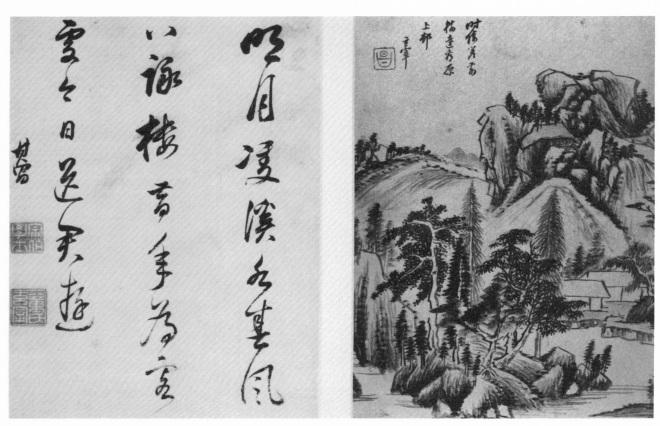

Leaf E

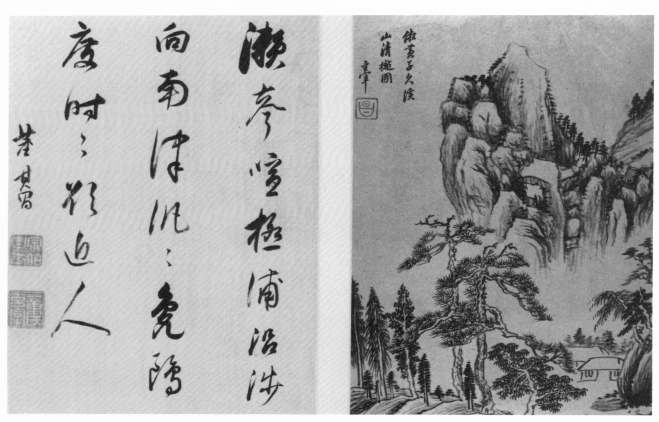

Leaf F

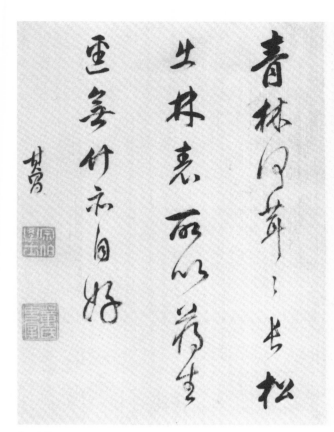
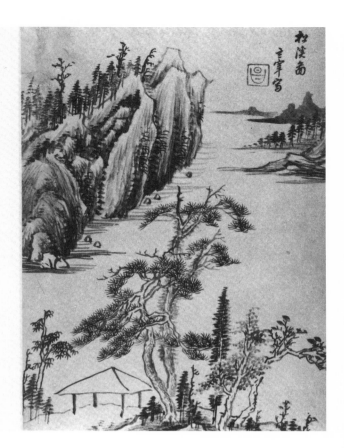

Leaf G

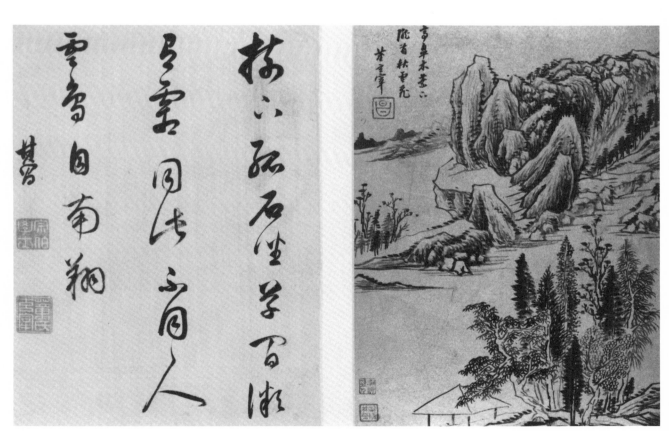

Leaf H

6 ZHANG HONG (1577 - after 1652)

Landscape: Boating in the Moonlight

Fan, ink and color on gold paper
17 × 51.3 cm

Traditional painting histories record little of the life of the Suzhou artist Zhang Hong, although significant praise is given his paintings by such critics as Zhang Geng (*Guochao Huazheng Lu*, 1254). Modern writers (such as Cahill, *Distant Mountains*, 39-59) have found in his paintings a refreshingly naturalistic approach, interpreting his work as a direct response to actual landscape scenes in shifting light and atmosphere. Zhang's remarkably large and varied corpus of surviving works shows a painter experimenting with color, ink and composition to create fresh scenic views for his native region's appetite for paintings of its many landmarks. Like his contemporaries Chen Guan [13] and Sheng Maoye [9], Zhang was a professional painter. His works included figure paintings as well as landscape scenes.

Bearing only the signature and seal (*Zhang Hong zhi yin*) of the artist, this fan features two boldly juxtaposed compositional elements: a deep stretch of moonlit lake, and looming bluffs with nighttime silhouettes of scrubby trees and a stream bed feeding into the marshy lake. The smudgy ink of the bluffs and the patterned waves and grasses reflect Zhang's typically direct rendering of forms. In his work, like that of Sheng Maoye, the viewer senses a freedom from the conventionalized texture strokes which dominated the work of contemporary literati painters. The fan may illustrate poet Su Shi's nostalgic nighttime visit to the Red Cliff, based on his prose poem written in 1082.

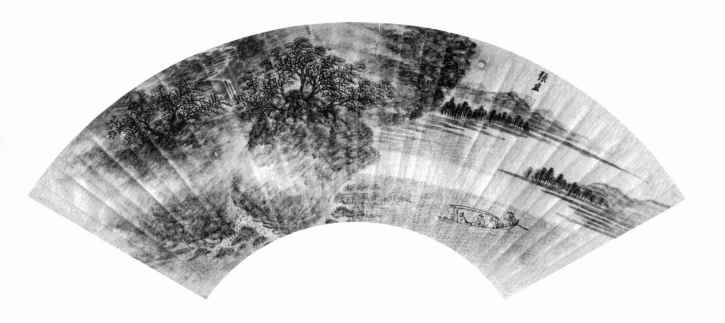

7 WU BIN (active circa 1583 - circa 1626)

Landscape

Fan, ink on gold paper
18.2 × 53.6 cm

Wu Bin was a professional artist from Fujian province who gained the notice of the Ming court and was called to service at the Nanjing capital. His prodigious talent is apparent in his extant paintings: Buddhist deities rendered with convincing super-human caricature, court paintings delineated with precise detail, and fantastic land-scapes presented with all the objectivity of Wu's descriptive style.

Bearing Wu Bin's signature and seal (*Wen zhong shi*), this work is one of only a few fans in the artist's well-published oeuvre. Its closest counterpart is a fan in the National Palace Museum (*Style Transformed*, no. 040). Here, on gold paper, Wu has sketched a casual work, one which might well have been painted rapidly for a patron of scholarly background likely to appreciate the unfettered ease of its brushwork as well as the subtle ethereality of its composition.

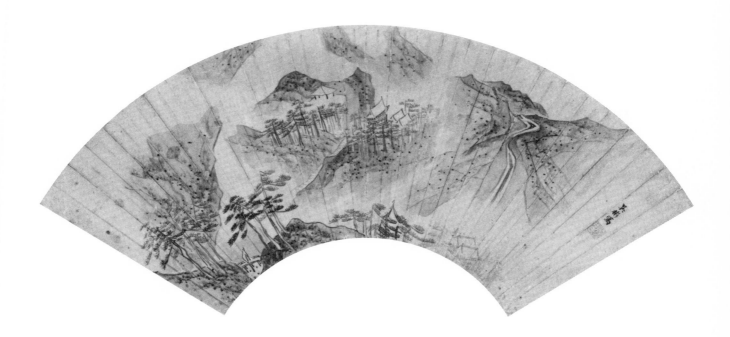

8 LAN YING (1585 - after 1664)

Conversing on Ancient Matters in Snowy Mountains

Hanging scroll, ink and color on silk
186.7 × 79.8 cm
Illustrated p. 10

Lan Ying's reputation as an artist lost much of the ground in posterity which it had gained during his lifetime. Zhang Geng (*Guochao Huazheng Lu, shang,* 12-13), following his elders' opinion, spoke disparagingly of his art. Shen Zongqian (in Yu Jianhua, *Zhongguo Hualun Leibian,* 866) considered him heretical. Least expected of all, he came to be viewed as the last master of the Zhe School. In his own mind, Lan might well have considered himself a follower of Dong Qichang, and therefore the very antithesis of the Zhe.

Indeed, throughout his life Lan Ying practiced what the aging Dong Qichang had taught. First, like other artists of the time, he adopted the practice of *fang,* in which a painter utilizes a range of ancient masters to stimulate the creative act. Second, the ancient masters were limited to a sanctioned group, those deemed to be in the Southern School, primarily Dong Yuan, Juran, Mi Fu and his son Mi Youren, Zhao Mengfu, and the Four Great Masters of the Yuan. Much of Lan Ying's painting is of the *fang* type and adheres to this range of styles clearly and distinctly, although he also made overtures to the art of Li Cheng, Fan Kuan, Li Tang and others. Given such a pedigree, Lan Ying should not have been even remotely associated with the Zhe School. Only his birth in Hangzhou, Zhejiang, offered a convenient excuse for that unwarranted association.

Lan Ying in his youthful years aspired to be one of the *wenren* painters and eagerly sought out Yang Wencong, Chen Jiru and perhaps Dong Qichang as mentors and patrons. He was willing to put aside his earlier flirtation with figure painting to devote himself to landscape and to plants, like orchid and bamboo, acceptable to the literati. He also displayed his literary flair in long poems of a eulogistic nature, which were included as inscriptions on paintings. But alas, his credentials were less than sound. So he admits, in the long colophon appearing on *Lofty Mt Song,* a eulogy dedicated to a former governor:

> I was born with a reckless nature,
> A simple wandering soul.
> My fame reached you, oh noble one.
> In flickering lamplight, my soul soars through wind and rain.
> You, who are worthy, forsake your worthiness.
> I, who am lowly, forget my lowly state....

It did not help that he was a *buyi,* a commoner, compelled by circumstance to turn painting into a career. In a world dominated by scholar-officials, this cast him in an unfavorable light. In time, particularly after the dynastic change, the aging master

appears to have resigned himself to his lot. He may still have maintained a link with friends in poetry circles, but his inscriptions, which are our only gauge of his inner state, grew terse and less revealing. Ironically, his commissions appear to have increased: he even painted on walls and in gardens, and supplied landscapes as backdrops for portraits of his contemporaries. His network of patrons was extensive, covering Jiangnan's major cities, including Shaoxing, Jiaxing, Yangzhou and his native Hangzhou.

Fore-doomed though he may have been, Lan Ying was an artist of great visual power and originality. His paintings can be as varied and distinct as the range of stimuli which precipitated them. But the variety in no way conceals his personal touch. Vibrant brushstrokes, crisp execution, intricate counterpoints and sonorous orchestration made him perhaps a shade less reserved than the typical *wenren* painters, but reveal in him a robust *élan*. In his late works, the surface darkens, and the artist could not resist the appeal of 'burnt ink,' with which he brought images to a full impact amidst thinly foliaged trees and lichen-encrusted rocks.

Conversing on Ancient Matters in Snowy Mountains is painted, according to the inscription, in the stylistic idiom of Fan Kuan:

> Emulating the method of Fan Kuan's *Conversing on Ancient Matters in Snowy Mountains*, done in the Wanhe Songtao [Studio] in West Stream. [Signed] Shitoutuo ['Stone Priest'] Lan Ying, [artist's seals] Lan Ying zhi yin, Tianshu.

The painting bears little relation to Fan Kuan's famed *Travellers in the Mountains and Ravines*, and the dots, often executed in ink and then centered with malachite green cannot even be described as a distant echo of the 'rain drop *cun*.' We look in vain for the usual attributes of the landscapes by this Song master, except for the low profile of barren and gnarled trees and the angular rock outcroppings. For Lan Ying, however, these would suffice.

The mature handling – a willingness to let the brush leap across contours and boundaries, and a rendering of trees and foliage that suggests rather than describes their form – supports a dating to the late 1650s or early 1660s. Confirmation of this comes from a painting of *Pine and Peonies* recently at auction in New York (Christie's, 3 June 1987, lot 113), which carries the only other known reference to the Wanhe Songtao studio mentioned in the inscription here and bears a date of 1658.

9 SHENG MAOYE (active circa 1594 - circa 1640)

Landscape: Saying Farewell in the Moonlight

Dated 1621
Fan, ink on gold paper
18 × 51.5 cm

A professional artist in early seventeenth-century Suzhou, Sheng Maoye is only briefly mentioned in standard biographies of artists. Nevertheless, his surviving works are numerous, and his style is distinctive for its suffused atmospheric effects, achieved through stippling, ragged brushstrokes and applied wash.

The present work, dated to 1621, is close in style to a number of Sheng's surviving fan paintings from the 1620s (a particularly close example is a fan dated 1623 in the Murakami collection, Suzuki, JP27-027-1). Typical are the wide branching trees silhouetted against heavy night-lit mists, and the anecdotal use of figures and cottages, paths and streams. Here the brushwood fence and its thatched gate provide a sense of the particular. As in many of his paintings, the artist has inscribed a couplet of poetry:

> White sands, green bamboo, the waterside village at dusk,
> Saying farewell at the brushwood gate, the moonlight is fresh.

> Painted in the first year of the Tianqi reign [1621] on the Double Ninth [ninth day of the ninth month – the Chongyang festival day], [signed] Sheng Maoye, [artist's seal] Yuhua.

Cahill has suggested that these omnipresent lines of verse were selected by Sheng to suit the mood of his finished paintings (*Distant Mountains*, 37). Indeed, here the painting is not so much an illustration of the verse as the verse is an embellishment of the painting.

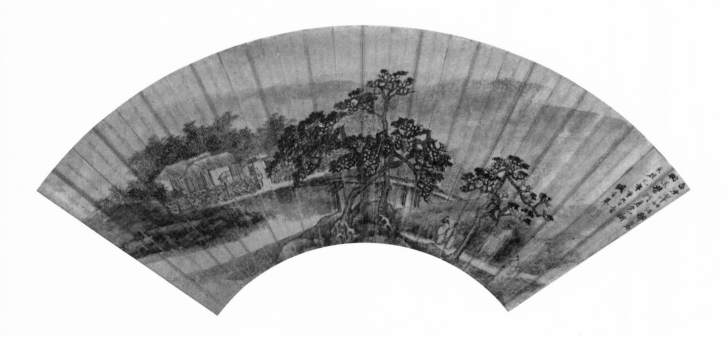

10 SHEN HAO (1586 - circa 1661)

Landscape

Dated 1640
Handscroll, ink and color on silk
42.2 × 468 cm

In 1640, when he painted this scroll, the Suzhou artist Shen Hao inscribed it:

> Dachi [the 'big idiot,' Huang Gongwang, 1269-1354] was no idiot. He handled the brush and ink tightly. His autumn forests, lakes and islets stretch beyond any limit. Painted at the Yunyuan Buddhist pavilion of Lake Wu, in the autumn month [the ninth month] of the *gengchen* year [1640]. [Signed] Quchan Shen Hao, [artist's seals] Shen Hao, Langqian.

Some years later he added:

> This was painted when I lived in seclusion in a Buddhist temple. Looking at it again today, I had almost forgotten its original appearance. I inscribe it for amusement. [Signed] Hao, inscribed at Chongan Songti. [Artist's seal] Langqian.
>
> [translations by Wai-fong Anita Siu]

Later in life, Shen had indeed forgotten the experimental and sometimes harsh style of this scroll, for by 1652 he had developed his characteristic manner so beautifully evident in the Elliott family album dated to that year (*Images of the Mind*, no. 32). This cleaner, crisper, more angular approach informs several of his undated works, including another album in the Drenowatz collection (Li, no. 21). But other extant works, including the recently published hanging scroll in the Hutchinson collection (Ecke, *Wen-jen Hua*, no. 8) and the album in the Guangzhou Art Gallery (*Paintings of the Ming and Qing Dynasties*, no. 22), seem to belong to a different, and no doubt earlier, chapter in Shen's life. These works have in common a broad eclecticism (Cahill, *Distant Mountains*, 30, has called Shen 'nearly always a derivative' artist) and a conservatism emphasized by their silk grounds.

The present painting helps to further define this emerging portrait of a shadowy figure best known not for his painting but for his writings about painting. Dated to 1640, this silk-ground scroll stems ostensibly from the style of the Yuan artist Huang Gongwang, but in fact it borrows profoundly from the leading master of neighboring Songjiang, Dong Qichang [5]. The second half of the scroll, particularly its boldly articulated land masses, could only have been painted by someone familiar with Dong's inventions. Shen was no doubt aware of the new Songjiang style, for his writings mention a rivalry between the Songjiang and Suzhou schools (translated in Cahill, *The Distant Mountains*, 30).

Although Shen criticizes the parroting of the old masters, he took his own artistic inspiration more or less directly from past painters. Huang Gongwang, his model here, continued to hold a special fascination for him, for in 1658 he made a free copy of that artist's masterwork, *Dwelling in the Fuchun Mountains*.

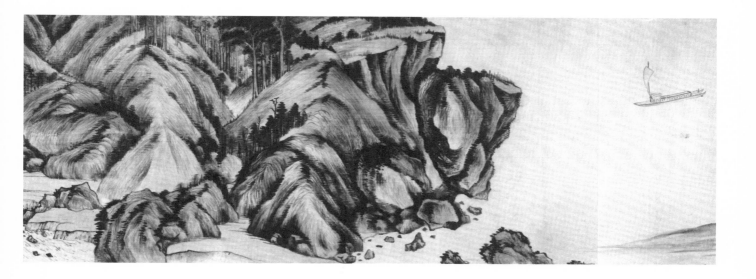

11 WEN SHU (1595-1634)

Flowers and Rock

Fan, ink and color on gold paper
15.9 × 49.5 cm

A descendant of the illustrious Wen family, Wen Shu probably learned painting from her father Wen Congjian (1574-1648), a great-grandson of Wen Zhengming (1470-1559), and yet her exquisitely rendered flower paintings have little to do with the simple landscapes which survive from her father's hand. (For a full biographical study of Wen Shu and a discussion of her family background, see Laing in *Jade Terrace*, 31-33; for works by Wen Congjian, see for example Suzuki, A16-052 and JM3-070.) Instead her works recall a manner of Wu School flower painting ultimately associated with Chen Chun (see *Jade Terrace*, 59-60). A more immediate and contemporary parallel can be drawn with the flower compositions of the minor painter Wang Qi, active in Suzhou circa 1600-37.

The painting, signed 'Zhaoshi Wen Shu' (artist's seals: *Wenshu, Duanrong*), compares closely with a fan in the Honolulu Academy of Arts (Ecke, *Poetry on the Wind*, no. 44) which is dated to 1627. Laing in *Jade Terrace* has suggested that when her family fortunes declined Wen Shu turned to painting for income. This fan and several others painted between 1627 and her death in 1634 may well have been executed for this purpose.

Published: *Jade Terrace*, 185.

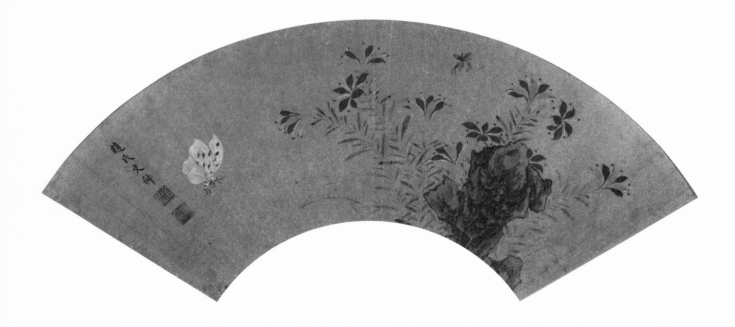

12 SHEN SHICHONG (active circa 1607 - after 1640)

Misty Landscape

Dated 1623
Handscroll, ink and color on paper
22.5 × 261.9 cm

Biographies of Shen Shichong often emphasize the artist's practice of ghost painting for Dong Qichang (Siren, V, 23). However, the Dong Qichang style reflected just one side of his artistic persona – the other side found in paintings like the present handscroll. It is a manner which he learned from his teacher Zhao Zuo (circa 1570 - after 1633), a manner which critics dubbed the Yunjian style, using the old name for Songjiang, the city where all three of these artists were active. Characteristic are the indistinct quality of the landscape created by dabs and washes of ink overlain with textural brushstrokes. The result is an atmospheric quality of great appeal. Shen manipulates reserved paper to further suggest patchy mist and as counterpoint he adds casually delineated cottages and figures, the latter emphasized by the application of bright color. His loosely organized composition (described by Cahill in reference to a similar work as 'pleasantly untidy jumbles,' *Distant Mountains*, 82) is punctuated by scraggly trees.

A survey of extant, dated paintings suggests that Shen's works in this style date primarily to the early 1620s. The present handscroll, which bears four unidentified collectors' seals, was inscribed by the artist:

> Painted in the eighth month, autumn of the *guihai* year [1623].
> [Signed] Shen Shichong, [artist's seal] Ziju.

The painting compares closely to the well-known handscroll of 1622 at Stanford (Suzuki, A36-012). Earlier works seem more closely based on the ancient masters (see *ZGSHT*, I, 1-039, dated 1610) while later works may reflect his close association with Dong Qichang.

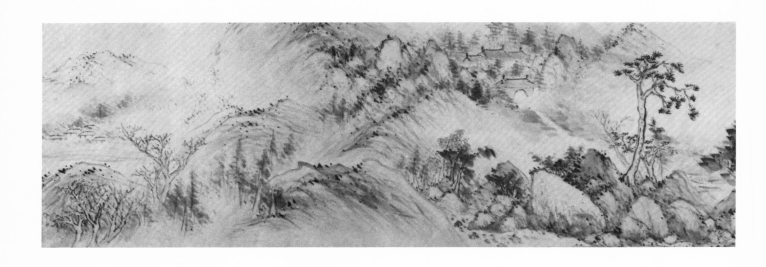

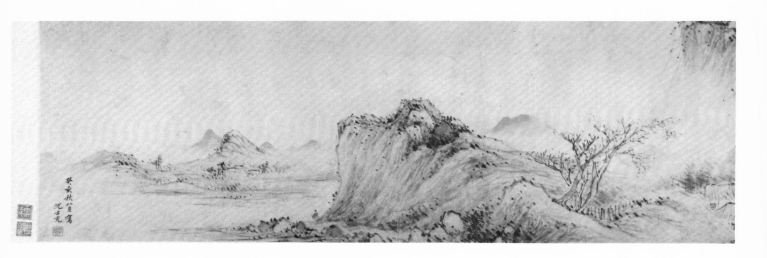

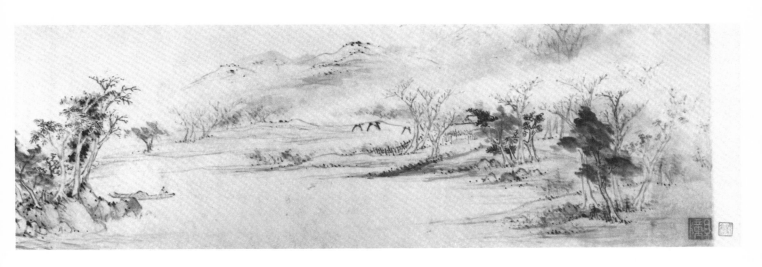

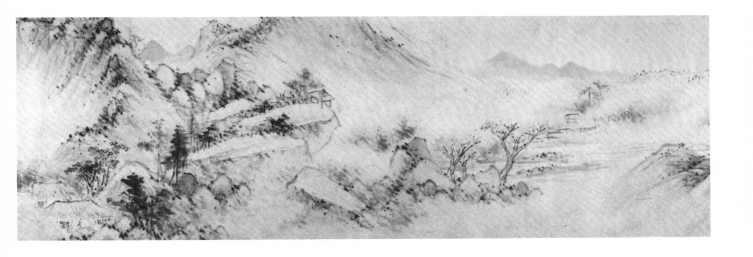

13 CHEN GUAN (active first half 17th century)

Landscape

Dated 1647
Handscroll, ink and color on paper
30.2 × 286.4 cm

No clear picture emerges from the scant biographical information on Chen Guan. His extant paintings are so diverse in style as to prompt one scholar to stretch his dates of activity backward well into the sixteenth century (Chu-tsing Li, I, 78). Worse still, a misreading of his name caused his biography and extant works to be listed under Chen Lo in Siren's standard reference (V, 28, and VII, 165-66). Traditional biographies record him as a painter in Suzhou whose works based on the styles of Zhao Boju (died circa 1162), Zhao Mengfu (1254-1322) and Wen Zhengming (1470-1559) were sought after by visitors to the region. In later life, he retired to Tiger Hill just outside Suzhou, devoting himself to poetry and the arts. A recent study (Laing, 107-8) compiling further information from diverse sources, has identified him as a collaborator with Cheng Jiasui (1565-1634), Wen Congjian (1574-1648), and Sheng Maoye [9], and as a friend of the scholar and critic Li Rihua (1565-1635). The same study has proposed a birth date of 1563. While Cahill (*Distant Mountains*, 33) has suggested that Chen was a professional or commercial artist, Li (I, 77-79 and 83-84) has emphasized his eclectic approach.

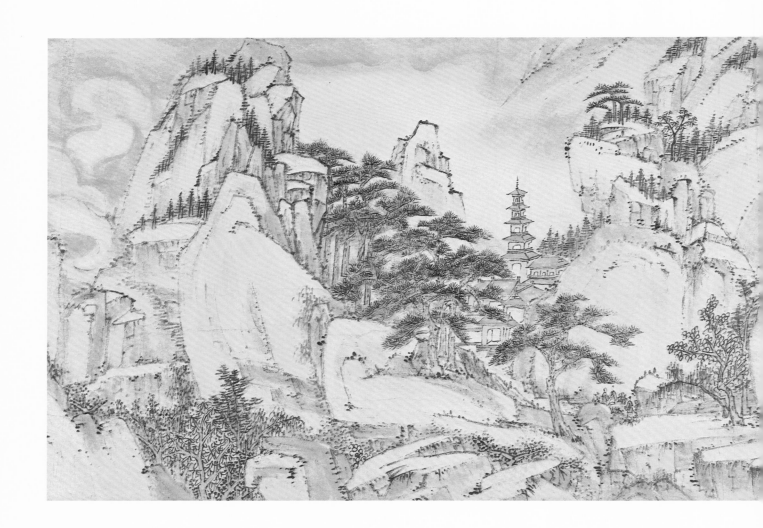

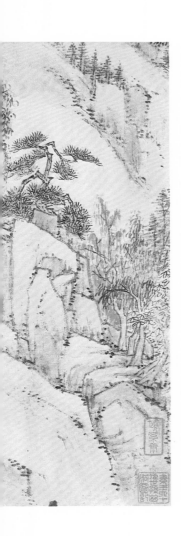

This superb scroll differs from Chen's best-known extant paintings, for example the slightly archaizing, late Wu style *Landscape with Cranes* (see Cahill, *Restless Landscape*, pl. 8), but is close in style to two of his extant fans, one in the Metropolitan Museum and the other in a private collection in Japan (see Suzuki, A1-083 and JP64-108-28). These works have much in common with the spare and descriptive landscapes of the contemporary Anhui School, rather than the delicacy and prettiness associated with the later Wen Zhengming tradition.

The composition with its panorama of temples and cottages, mountains and cultivated fields, stems from a longstanding Suzhou tradition in which local scenes are set into an idealized framework. Chen's unique treatment of swirling mist has its parallel in his archaizing style, though here, of course, the motif is rendered in soft washes of ink. A similar preoccupation with thick clouds of mist dominates his hanging scroll of 1630 in the National Palace Museum, Taipei (see Cahill, *Distant Mountains*, pl. 2), as well as the fan in the Drenowatz collection (Li, II, fig. 14). As to the proper rendering of the cyclical date, which may be read as 1587 or 1647, the earlier date, when the artist was likely in his twenties, seems improbable: this is not the work of an emerging artist.

Chen inscribed the scroll in *lishu*, clerical script, with a poem which seems to reflect the landscape of the painting:

> To plant apricots and raise plums,
> A man of lofty spirit chisels the rocks and builds a house.
> All the year round, there is green shade of trees.
> White clouds drift by, stretching and rolling into the desolate forest.
> There are times when all sounds are hushed;
> A humming sound flows through the air.
> This sentiment cannot be reproduced,
> Nor can one find elsewhere such beautiful scenery!
> All we can do is to go into a thousand-peak range
> And play the five-stringed lute together.
> Peach blossoms prosper beside green waters
> So that I forget it is deep spring already.

> In the fourth month of the *dinghai* year [1647], written by Chen Guan at Xiu Fozhuang. [Artist's seal] Chen Guan.

> [translation by Jane Wai-yee Leong]

The painting bears the seal of the Anhui collector Zhu Zhichi (active mid-seventeenth century) and three other collectors' seals.

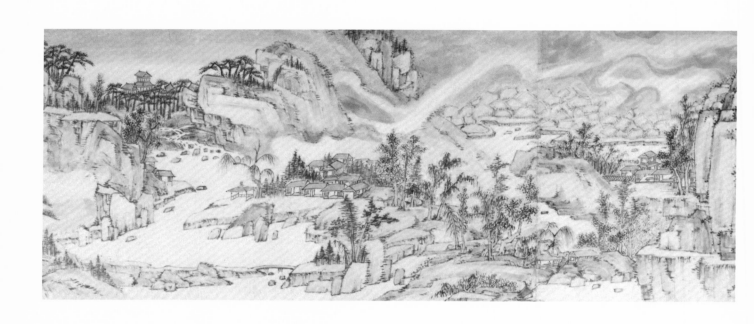

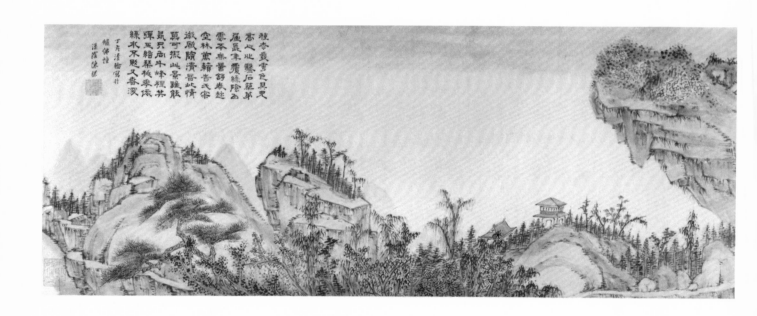

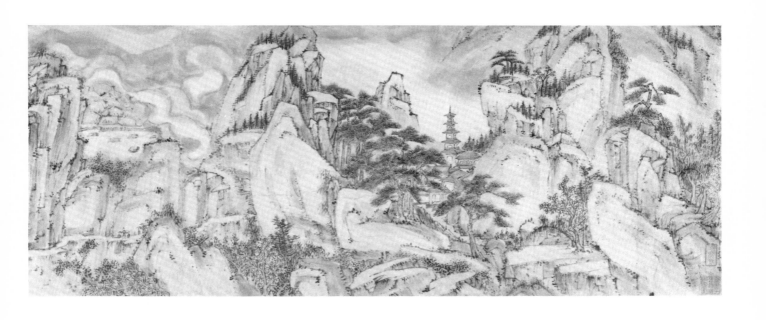

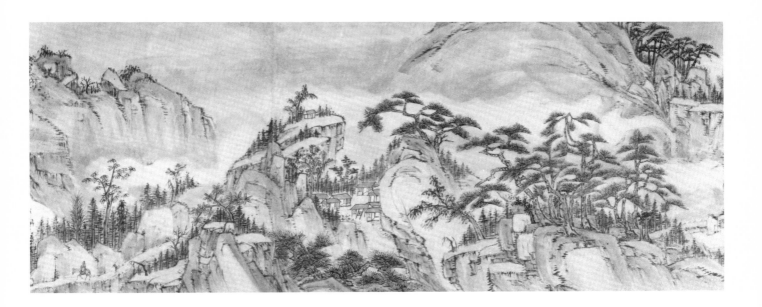

14 ZHA SHIBIAO (1615-98)

Landscapes

Dated 1687
Album of twelve leaves; ink or ink and color on paper
Each leaf 31 × 22 cm

An artist whose early work bore the influence of Hongren (1610-64), the leading master in his home province of Anhui (see Cahill, *Shadows of Mt. Huang*, 102-08), Zha Shibiao has come to be recognized as a painter whose late work, done mostly in Yangzhou, helped set the direction for the flourishing school in that city during the eighteenth century. Painted as the artist entered his eighth decade, the present album provides new evidence of this artist's confident and richly varied late style. A full series of dated albums spanning Zha's career, each a set of leaves inspired by the past masters, can now be identified: 1668 (Weng collection, Suzuki, A13-047), 1672 (National Palace Museum), 1674 (Tokyo National Museum, Suzuki, JM1-230), 1684 (Cleveland Museum of Art, *Eight Dynasties*, no. 226), and the present album dated to the year 1687.

The album is a mixture of freely composed paintings and compositions following specific models. Leaf D, for example, is based upon the mature style of Ni Zan (1301-74), which held great attraction for later painters. Anhui School painters were particularly fond of reviving its spare and elegant austerity. Zha presents the conventional hut in a sparse grove of trees giving way to a broad expanse of water suggested by reserved paper. The jutting cliff appears in several renderings of the Ni Zan style as well as in works attributed to the master. Leaves F and J are equally successful in evoking the ink-dot landscape style of Mi Fu (1051-1107) and the lush dots and blunt brushstrokes associated with Wu Zhen (1280-1354). Leaf B, after Shen Zhou, is unique in the album for its loosely composed and sketchily brushed scene of cottages by a shore. Zha's fascination with the bold, blunt brushwork of Shen Zhou can be seen in other works, including *River Landscape in Rain* dated to the same year as this album (Fu and Fu, 152-55).

Of the paintings in Zha's personal style, most typical is leaf L, with roughly drawn anecdotal figures and awkward trees enlivening a landscape of simple forms but masterful strokes of the brush. A single stroke in the lower right-hand corner seems at once to delineate and model the foreground land mass. A smaller mass of shoreline juts in behind the trees, serving a function similar to that of the middle-ground land masses in leaves four and eleven. The distant mountains are defined in brushwork like that in leaves G and J, following Huang Gongwang and Wu Zhen. Thus it seems that these studies after ancient masters, different as they are from Zha's own style, nonetheless served the artist as proving grounds for his experiments in composition and brushwork.

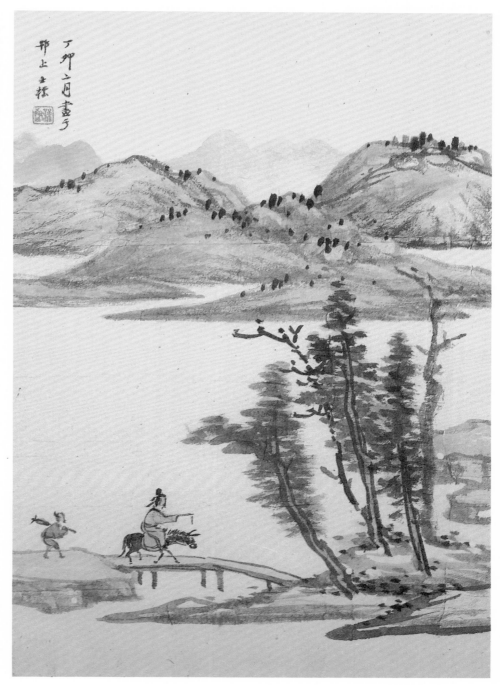

Leaf L

Leaf A

Setting off with the birds, the boat will sail afar.
The sky mingles with the forest below.

[Signed] Shibiao painted this theme from Tang poetry,
[artist's seal] Meihe.

Leaf B

After the style of Baishiweng's [Shen Zhou's]
Returning to the Cottage. [Signed] In late spring of the *dingmao*
year [1687], Shibiao. [Artist's seal] Erzhan.

Leaf C

Fishing on an Autumn Stream.
[Signed] Painted by Shibiao, [artist's seal] Erzhan.

Leaf D

Spring Pavilion and Distant Cliff is an authentic work by
Yuweng [Ni Zan]. Shibiao [here] imitates it.
[Artist's seal] Meihe.

Leaf E

Reflections of Sails in Lake Dongting.
[Signed] Painted by Shibiao while lodging at Dai Yenlou
[The Terrace for Awaiting the Geese], [artist's seal] Erzhan.

Leaf F

Cloudy Spring, in the style of Xiangyang Manshi [Mi Fu].
[Signed] Zha Shibiao, [artist's seal] Erzhan.

Leaf G

I copy a portion of Zijiu's [Huang Gongwang's] *Fuchun
Mountains*, which has brushstrokes following closely the style
of Dong Yuan. Undoubtedly, because of its lofty sentiment,
it should rank first among Zijiu's paintings. [Signed] Shibiao,
[artist's seal] Erzhan.

Leaf H

Returning Sails in the Gorges, by Jiulong Shanren [Wang Fu].
[Signed] Shibiao, [artist's seal] Meihe.

Leaf I

Literary Gathering at a Mountain Pavilion.
[Signed] On the Day of Purification of the *dingmao* year
[1687], written by Shibiao, [artist's seal] Erzhan.

Leaf J

Temple amidst a Range of Mountains by Meihua Daoren
[Wu Zhen]. [Signed] Imitating its idea, Shibiao,
[artist's seal] Erzhan.

Leaf K

The style of *Streams and Mountains* by Cao Yunxi [Cao Zhibo]
seems to resemble that of Yunlin Laoren [Ni Zan]. In fact,
they are different. Only those who are knowledgeable can
distinguish this. [Signed] Shibiao, [artist's seal] Mouhe.

Leaf L

Painted at Hanshang [Yangzhou] in the second month of the
dingmao year [1687]. [Signed] Shibiao, [artist's seal] Meihe.

[translation by Jane Wai-yee Leong]

The album includes a frontispiece with the title *Jixin
Qingshang* ('Heartfelt Enjoyment') written by a later Japanese
collector. A collector's seal is obliterated from each leaf.

乌与扁帆
远天逢野
树低亇描
画君人语
京

Leaf A

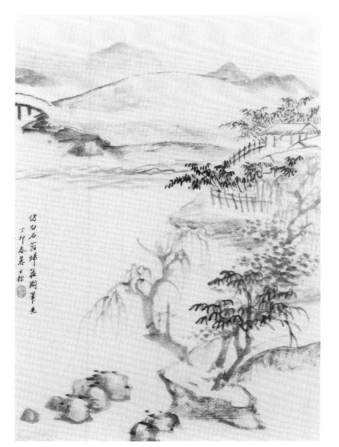

仿白石翁晴牌阁笔意
丁卯春暮士栖

Leaf B

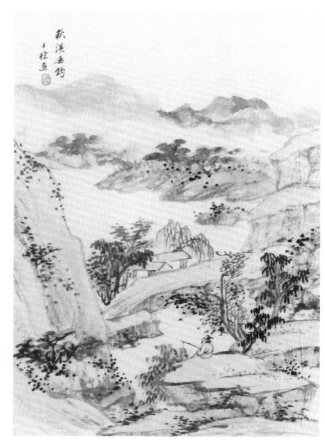

秋溪垂钓
士栖画

Leaf C

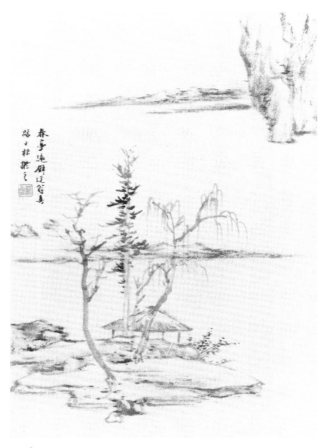

春宁逸群逢翁真
福士栖拟之

Leaf D

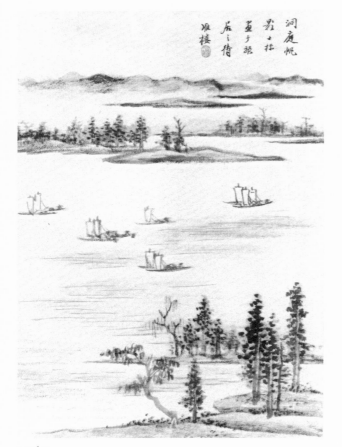

洞庭帆
霧十椏
墨于祝
居士倩
雅樓

Leaf E

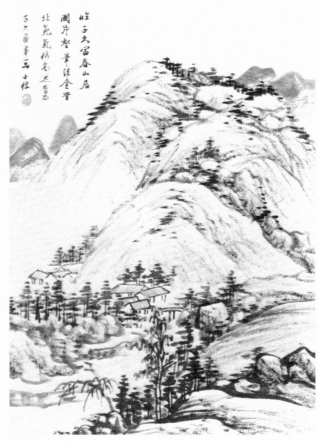

臨子久富春山居
圖片整筆法金堂
北苑氣接高志高為
子久畫筆石士椏

Leaf G

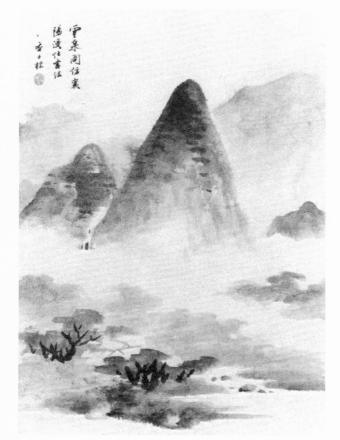

雲泉圖仿襄
陽溪化書法
古士椏

Leaf F

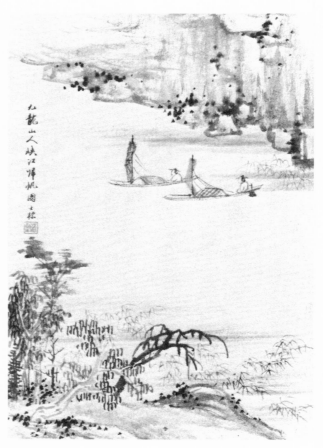

大龍山人峽江歸帆圖士椏

Leaf H

山亭高會
丁卯暮秋日
士標寫

Leaf I

曹雲西畫法
山圖筆法少
雲林老人似用
實與減者鑒
天標茂

Leaf K

梅華道人層巒
士標倣意

Leaf J

15 GONG XIAN (circa 1618-89)

Landscape in the Style of Dong Yuan and Juran

Dated 1668
Hanging scroll, ink on silk
158 × 54.5 cm

This landscape hanging scroll fills a major gap in the documentation on Gong Xian. Datable to 1668, it sheds new light on Gong's style during the later 1660s, a period which is pivotal for the emergence of his characteristic, somber style but for which there are few dated works (see Cahill, 'Early Styles,' 65 and 70; and Wu, 72). This painting, together with recently published works in Chinese collections (see for example *ZGSHT*, I, 10-023, a hanging scroll dated 1666), confirm that the transition from Gong's early, spare and linear style to his mature, ink-laden manner took place during these years.

By autumn of 1668 when this landscape was painted, Gong had returned to Nanjing from Yangzhou and had established the 'Half-acre Garden,' his small home- stead at the foot of Mount Qingliang. His use here of a seal calling himself *Banshanyeren* or 'Half-mountain-rustic' seems a play on the self-deprecating name he gave to his garden and evokes his ambivalent status as retired literatus and profes- sional painter. The same seal is noted in Contag and Wang (510, no. 5) on an album of 1668, and also appears in a well-known album of 1671 in the Nelson Gallery (Wilson, no. 8). As in many of his works, Gong's inscription here has a didactic tone, as if addressed to students (of which he had many) or to would-be connoisseurs:

> The three artists Dong Yuan [active tenth century], the monk Juran [active circa 960-80], and Fan Kuan [circa 960-1030] were all active during the same period. I have seen many authentic works of Juran. This work half resembles Juran's and half Dong Yuan's. This is because I like Dong's use of ink and Ju's brushwork.

> Dong Yuan and Juran are the painter's standard script. Fan Kuan, Mi Fu [1051-1107], Wu Zhongkui [Wu Zhen, 1280-1354], and Gao Fangshan [Gao Kegong, 1248-1310], are more like the running or grass scripts. Of those who came before, I consider Dong Yuan the founding father of painting. Later on, Shen Zhou [1427-1509] painted toward a great synthesis. Shitian's [Shen Zhou's] paintings after Huang [Huang Gongwang, 1269-1354]

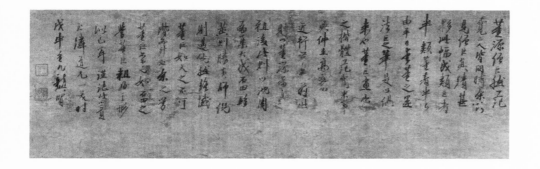

were better and when he followed the style of Ni [Ni Zan, 1301-74] he over-reached. But in the end he lamented that Dong and Ju are like heaven and cannot be reached. My paintings after Dong and Ju are like Shitian's after Dong and Ju, roughly similar in form and that is all.

Written for presentation to brother Yulin for his enjoyment, on the Double Ninth [ninth day of the ninth month] of the *wushen* year [1668]. [Signed] Gong Xian, [artist's seals] Banshanyeren, Xian.

[translation by Wai-fong Anita Siu]

Gong's preoccupation with Dong Yuan, the source of the dark-dotted style for which he is best known (see Wu, 79), is apparent here as well as in works dated to the early 1670s, including a well-known handscroll of 1674 in the Nelson Gallery (Wilson, no. 9) on which Gong refers to Dong Yuan as a founding father of landscape painting.

Returned from Yangzhou, where he may have seen some paintings by Juran, Gong here furthered his stylistic experimentation with the dotting and soft brushwork of the Dong Yuan-Juran tradition and began his manipulation of reserved highlights which would become the major means for creating the bizarre and often brooding imagery of his works of the 1670s. Here the method is apparent in the foreground, where the upper surfaces of land masses appear light because of his reserved silk technique. It also appears in the background mountain where he departs from the Dong-Ju tradition by introducing stark highlit masses played against dark ravines. The painting is almost entirely built up of moist-looking ink dots strengthened by linear contours, preserved from his early style, and of the patterns of walls and cottages. The composition derives from Yuan dynasty painting, especially the work of Wu Zhen, who is mentioned in the inscription. Thus the painting, as well as its inscription, has an art-historical significance, marking 1668 as the foundation for his boldly innovative works of the early 1670s.

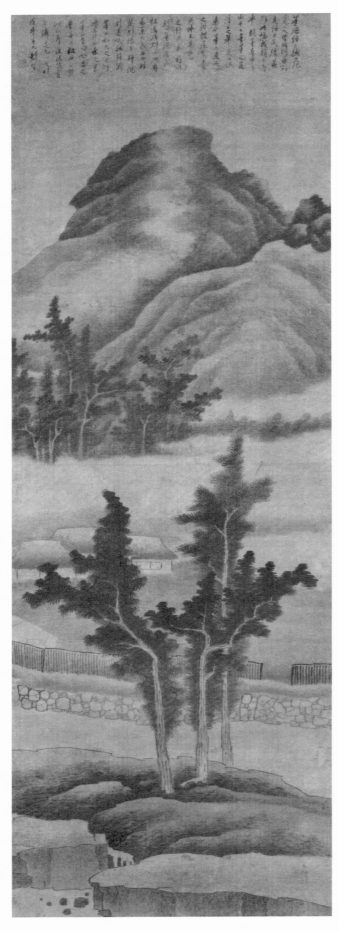

[15]

16 LI YING (active 17th century)

Landscape

Dated 1682
Hanging scroll, ink on satin
222 × 52 cm

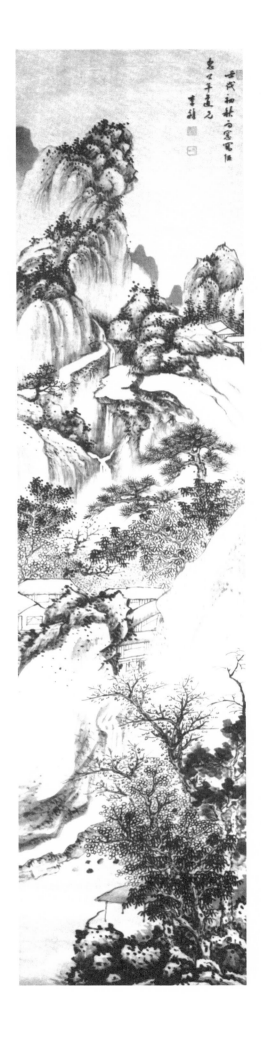

The painter and antiquarian Li Ying was a native of Taizhou, not far from Yangzhou (unlike other sources, *Tuhui Baojian Xuzhuan, juan* 2, 45, cites Yangzhou as his birthplace). This rare example of his landscape painting, brushed with a sure and competent hand in dark ink on satin, shows him to have been an artist worthy of recognition. Rounded rock faces spattered with lush dots of vegetation contrast with broad, dynamic cliffs of startlingly bare silk. Li's image of a remote and rugged mountainscape is then stabilized by his use of flat washes of ink to ground the composition between a body of water and distant peaks before a broad sky. Li has inscribed the work:

> In early fall of the *renxu* year [1682], by the western window, painted for the Taoist priest Hui Gongnian. [Signed] Li Ying, [three artist's seals].

With its rich dark ink-dots and the brooding impression created by juxtaposed highlights and dense concentrations of ink, the painting seems linked to the style of Gong Xian [15]. It is well known that Gong Xian gave many lessons in painting, but the identities of his students are less clear. Li Ying, from Taizhou and active in the Yangzhou region where Gong spent much of his time in his later years, might well have had a chance to study with him. When Manchu armies savagely attacked the city of Yangzhou in 1645, Gong Xian took refuge in Taizhou, Li's hometown, where he was tutor to the Xu family for about five years (*Images of the Mind*, 193). However, Gong's dark manner had not yet developed at that time, and Li Ying at any rate was probably too young to have known him then. Still, Gong made frequent trips back to the Yangzhou area in later years, and it is likely that Li knew Gong's paintings even if he did not receive direct teaching from him.

The painting bears the seal of a Japanese collector.

17 YAO WENXIE (1628-93)

Landscape: High Pavilion in Rocky Hills

Dated 1660

Hanging scroll, ink and color on satin

148 × 49.5 cm

Yao Wenxie, from Tongcheng in Anhui province, held a minor official post and received some notice as a poet and landscape painter. This hanging scroll, painted in the year after Yao received his *jinshi* degree, is one of only a handful of his extant or recorded works, all of which date to the 1660s. (For a painting in the H. C. Weng collection, see Suzuki, A13-006; for a recorded work, see Ge Jinlang, *Airiyinlou Shuhua Lu*, *juan* 3, 19.) This work is inscribed by the artist:

> Rocky hills and a high pavilion are sealed by five[-colored] clouds.
> Trees embrace the purple cliff under layers of blue mist.
> From the Milky Way comes continuous rain.
> By the sandy embankment, [I] await the descent of the dragon.

> Presented for the comment of the venerable Mr. Weng, the honorable poet, in autumn of the *gengzi* year [1660]. [Signed] painted by Yao Wenxie. [Artist's seals] Chen Xie, Zijingsan, and Genghu.

> [translation by Jane Wai-yee Leong]

The painting apparently remained in the Yao family collection until the nineteenth century, for it is inscribed at lower left 'Respectfully preserved by seventh-generation descendant Yao Yuanzhi. [Artist's seal] Yuanzhi.' Yao Yuanzhi (1773-1852) was a noted painter of the Jiaqing-Daoguang era. Three seals of unidentified collectors also appear.

The painting partakes of what has been identified as an Anhui province style (see Cahill, *Shadows of Mount Huang*) especially in its spare brushwork and towering landscape forms. The idiom of piled-up structural segments of landscape may be a regional conceit, but Yao Wenxie infuses his own elements into the composition: a rich variation in ink tone and in textural patterns, the appealingly awkward rendition of the cottage and the bridge, and the addition of the scholar (possibly self-referential) and attendant at lower right.

Published: Suzuki, JP14-020

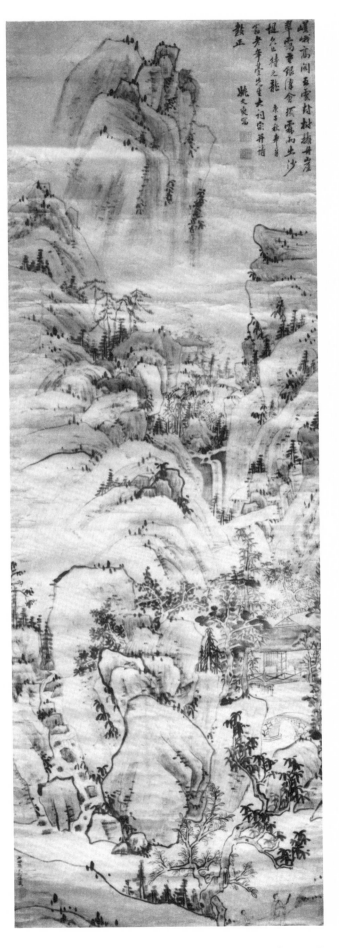

18 WANG HUI (1632-1717)

Southern Inspection Tour:
Benniu Zhen to Changzhou on the Grand Canal

Documented 1691-98

Handscroll, ink and color on silk

68.4 × 576 cm

From a relatively poor and undistinguished background in his native city of Changshu, Jiangsu province, Wang attracted the attention of Wang Jian (1598-1677) and later Wang Shimin (1592-1680), two prominent followers of Dong Qichang [5]. Inheriting a mantle of literati orthodoxy from these illustrious painters, Wang Hui became the outstanding professional artist of his time. When the Kangxi emperor sought a painter to design and oversee the execution of a series of scrolls commemorating his inspection tour of the south, Wang Hui was put forward as the best painter in the realm. In 1691, Wang Hui arrived in Beijing to begin the *Southern Inspection Tour Pictures (Nanxun Tu)* which would culminate some seven years later in twelve sumptuous and highly polished narrative scrolls depicting the emperor's 1689 tour of seventy days' duration. (For a full discussion of the Kangxi *Nanxun Tu*, see Hearn.)

This recently discovered handscroll of fifteen-and-a-half feet preserves roughly a third of the missing sixth scroll in the series. The stretch of the Grand Canal from Benniu to Changzhou, a distance of a little more than ten miles, is described here with meticulous representation of local landmarks, each identified by a brief title, particular recording of shops and houses, and lively rendering of the townspeople and the everyday activities of rural life. Preparations for the emperor's imminent arrival are in full sway, and members of the imperial retinue mingle with the local populace.

The considerable space and attention devoted to this short stretch along the Grand Canal appears generous in comparison to several more quickly moving scrolls in the series. The same might be said of the seventh scroll which depicts the stretch of some thirty miles from Wuxi to Suzhou (see Hearn, Table 2). Perhaps Wang Hui's design reflects a special fondness for this area, Changzhou being only fifty miles from his home village of Yushan near Changshu.

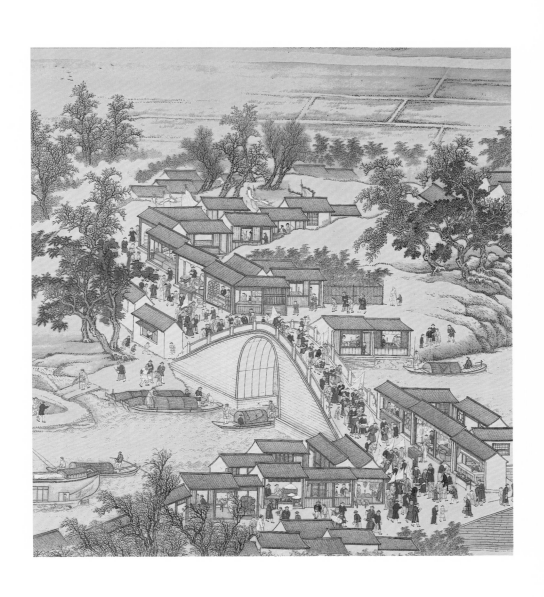

19 WANG HUI (1632-1717)

Landscape in the Manner of Zhao Lingrang

Dated 1713

Hanging scroll, ink and color on paper

141 × 39 cm

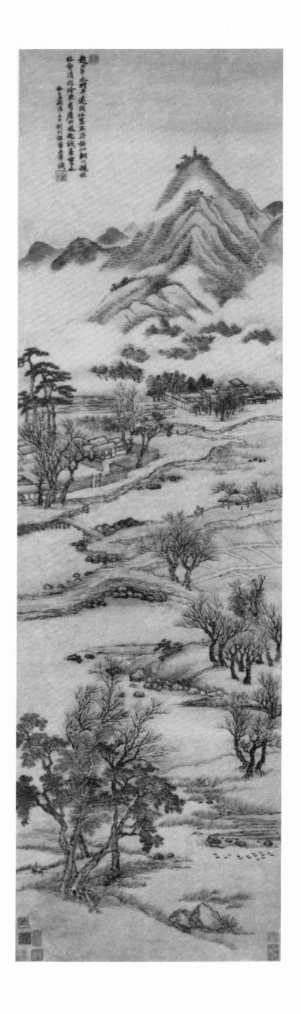

Throughout his long career, Wang Hui studied and copied paintings in the great collections of the Jiangnan region and eventually transformed the landscapes styles of ancient masters into a personal style of great consistency. He included Zhao Lingrang (active circa 1070-1100) among the Song and Yuan masters he imitated in his many albums of studies (see for example, *ZGSHT*, I, 6-18, 13th leaf; Suzuki, A12-002-1; and *Wang Hui Hua Lu*, nos. 13-3, 35-4, and 49-3). The manner continued to be an important source of inspiration into his last decade of life. In addition to this hanging scroll, painted when the artist was eighty-one years old, two extant hanging scrolls on silk dated to 1712 and 1715 took Zhao's work as model (see *ZGSHT*, I, 5-394, and *Wang Hui Hua Lu*, no. 51). On this more casual scroll on paper, Wang wrote:

> The composition and use of dotting and wash in the painting *Waterside Village in Level Distance* by Zhao Lingrang closely resembles the scheme of the *Wangchuan* [scroll by Wang Wei, 699-759]. The distant forest and the mountains are clear, with a sense of coldness and an otherworldly flavor. It is indeed a treasure! Painted three days after the beginning of autumn in the *guisi* year [1713]. [Signed] Jianmen Qiaoke Wang Hui, [artist's seals] Wang Hui zi yin, Gengyan, Haiyu, and Qinghui Laoren shinian bashi you er.
>
> [translation by Wai-fong Anita Siu]

Earlier that year, Wang had spent time reviewing some of his earlier paintings after old masters, including Zhao Lingrang, and had even added touches of color to some of them before having them mounted in an album (*Wang Hui Hua Lu*, 155). In Wang's later years, his follower Yang Jin often added figures and animals to his paintings. Yang may well have painted the small figures and water buffalo in this hanging scroll.

20 LAN MENG (active 1639-1701)

Landscape After Juran

Dated 1664
Hanging scroll, ink and color on silk
182.5 × 47 cm

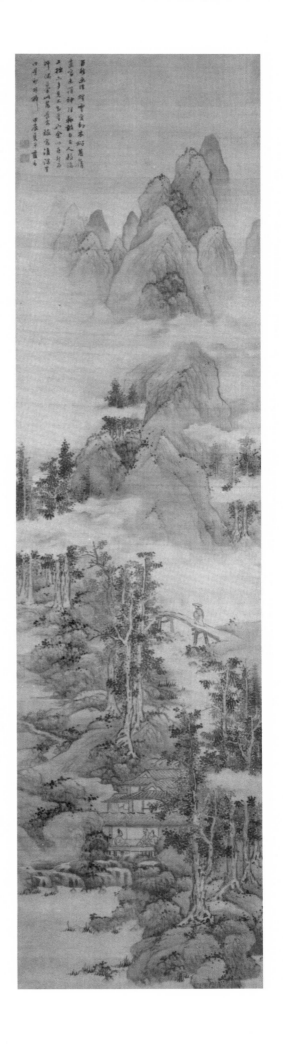

Not much is known about Lan Meng but that he was the son of Lan Ying, and that his pursuit of a scholarly career did not go beyond the local studentship, or *shengyuan*. *Tuhui Baojian Xuzhuan* (*juan* 2, 41) comments that he is 'skilled in painting landscapes, and is marvelous in evoking the spirit of Song and Yuan masters...,' particularly Ni Zan. It goes on to note that, while his brush may be devoid of strength, in rendering hills and peaks he achieves such crispness that the effect is not unlike the refreshing taste of 'icy pear and snow-chilled lotus root.'

The present hanging scroll, painted in 1664 when Lan was in Beijing, bears this inscription:

> Paintings by Juran are known for the ever-changing mystery of the mist and vapor as well as tall and lush forests. [In my day], I have known many painters who failed to grasp the spiritual principles of art, still comparing themselves favorably to ancient masters. They lack self-knowledge. I took Juran as my teacher and, during my Beijing sojourn, sought to emulate him in a moment of leisure. Whether there is a likeness or not is of little concern to me. On a summer moon, the *jiachen* year [1664]. [Signed] Lang Meng, [artist's seals] Lan Meng zhiyin, Yiyu Shi.

The painting is of a looser structure and evokes a gentler sentiment than his father's works. The familial touch is evident, however, in the rendering of the trees and figures, the cascades and the cottages. Painted in an elongated format reminiscent of the Wu School practice of a previous era, motifs are piled upon motifs on an ascending scale, defying depth and reducing mass to planes and silhouettes. As tall trees rise upward, peaks descend into the mist: there is a polarity of understated contrasts, subdued tonalities and moistened surfaces. As with the role of Fan Kuan in Lan Ying's *Conversing on Ancient Matters in Snowy Mountains* [8], here the 'image' of Juran exists only in the mind of the artist, providing no more than a point of departure as he improvises largely on his own terms.

21 WANG ZHENG (active late 17th - early 18th century)

Pheasants under a Crab Apple Tree

Hanging scroll, ink and color on silk
183 × 95 cm

Wang Zheng's biography (recorded in Zhang Geng, *Guochao Huazheng Xulu*, 1363-64) indicates that she was a respected woman scholar from Yangzhou. Having studied under the Qing scholar-official Xu Zhuo (1624-1713), she was employed as tutor to the daughters of the Manchu official Maci (1652-1739), a Grand Secretary best known for his participation in diplomatic negotiations with the Russians. As tutor in the Manchu household, Wang Zheng resided for a time in Beijing, likely before Maci's arrest in 1708 for interference in the selection of the heir apparent.

Wang Zheng's composition reveals a strong interest in the traditional, descriptive rendering of birds and flowers, deriving ultimately from the style of the Northern Song court painters and elaborated by traditionalist painters for the Ming court. Color is painstakingly applied and ink is used suggestively to render three-dimensional forms in an evocative space. Compositional forms are balanced to create a stable, even monumental impression. While these are the devices of a painter-craftsman of the academic tradition, Wang shows her literary background by inscribing a poem of her own composition:

> In the crab apple white-headed starlings talk among themselves;
> Among the rocks the pheasant calls out while the free-flowing river sounds.
>
> <div align="right">[translation by Howard Rogers]</div>

[Signed] Inscribed [and painted] by the woman scholar Wang Zheng of Han river [Yangzhou], [artist's seal] Tang zhuang.

Wang Zheng's awareness of court-sponsored painting during her stay in Beijing may account for the academic character – based ultimately on Northern Song models – which sets her work apart from that of most literary women of the period. Still, we may not have to look so far to explain her revival of Song bird-and-flower painting, for the approach aligns her work with the conservative architectural and landscape paintings of Li Yin and Yuan Jiang [23], both active in her native city of Yangzhou in the late seventeenth and early eighteenth century. She may also have been familiar with bird-and-flower paintings by Zhe School artists or those by Sun Ti (active seventeenth century) or Lan Ying [8], who had patrons in Yangzhou. A flower and rock composition by Lan Tao (the painting, dated 1679, is in the Hashimoto collection and is illustrated in *Chugoku no kaiga*, pl. 93; for Lan Tao, see entry 22), descendant and follower of Lan Ying, compares closely to Wang's in the treatment of the rocks and tree trunk as well as the heavily colored flowers. Wang's composition, however, retains a full spatial setting whereas Lan's tree and rock exist in a single plane.

Published: Suzuki, JP14-108; Weidner, *Jade Terrace*, 184.

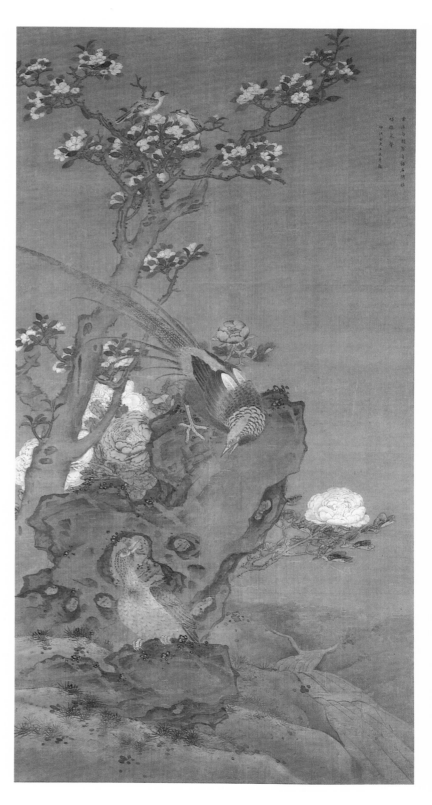

22 LAN TAO (active 1671-1708)

Landscape in the Yuan Style

Dated 1708
Hanging scroll, ink and color on silk
174 × 42 cm

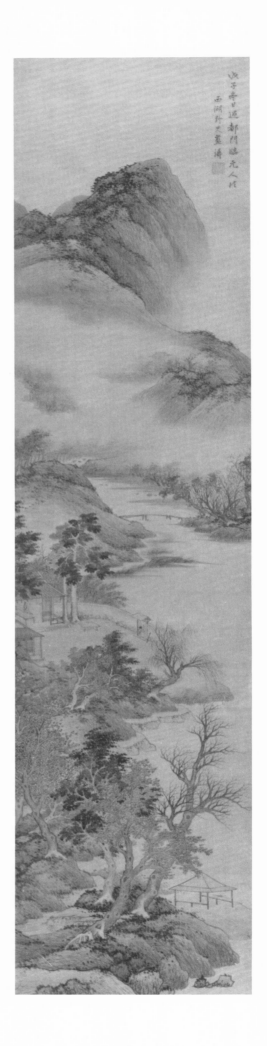

The son of Lan Meng and grandson of Lan Ying, Lan Tao predictably followed in the family tradition. Zhang Geng (*Guochao Huazheng Lu, shang,* 12-13) found that his *Withering Paulonia and Chrysanthemums* harbored 'ancient methods' while his trees and rocks were tinged with his '[grand]father's habits.' The author of *Tuhui Baojian Xuzhuan* (*juan* 2, 49) by contrast called attention to his refinement in small paintings.

While these comments are not particularly revealing, a glance at the *Landscape in the Yuan Style* shows that it is more broadly allied with Lan Meng's work in the present exhibition [20] than with the grandfather's [8]. The paintings share a tall and narrow format, where landscape motifs are placed in close proximity and in an ascending scale. Also similar are the unhurried pace and quiet atmosphere. The tone here is perhaps a touch more somber than Lan Meng's, and in place of the latter's predilection for repeated upward thrusts, a stream meanders through layers of rounded hills to its hidden source. There is also an echo of Wang Meng, as the *cun* here recalls the Yuan master's *jiesuo* ('loosened strands of rope').

Lan Tao inscribed the scroll:

On a winter day of 1708, I was passing through the capital and painted this in emulation of Yuan style. [Signed] The Fictitious Historian of West Lake, Lan Tao, [artist's seal] Lan Tao zhi yin.

23 YUAN JIANG (active circa 1680-1740)

Examination Time in the Capital

Hanging scroll, ink and color on silk
182.5 × 41.5 cm

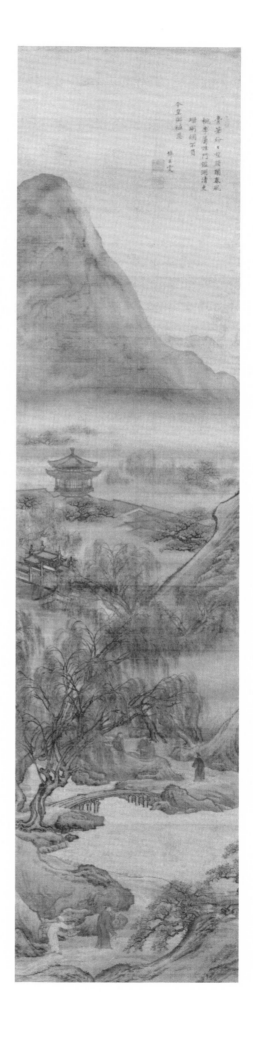

Recent studies (Cahill, 'Yuan Chiang and His School'; Nie Chongzheng, *Yuan Jiang yu Yuan Yao*) have shown the professional artist Yuan Jiang to have been an extraordinarily productive painter in the brightly colored, archaistic mode adopted and popularized among conservative artists and patrons in eighteenth-century Yangzhou. Little in Yuan's published *oeuvre* prepares us, however, for the contemporaneity of the narrative in this painting. Rather than illustrating the legendary or historical themes which came to be the hallmark of the Yuan School, this hanging scroll presents the viewer with real Qing scholars wearing blue robes and the queue hairstyle mandated under Qing rule. This departure was clearly occasioned by the wishes of the patron, one Fu Wangwen, who inscribed the painting:

> Pounding brushes in commotion, they look toward the
> locked doors,
> To whose gate will the spring wind entrust the peaches
> and plums?
> This pure official from Jianhu [Lake Tai] with coral net
> Would not be ungrateful for the present August One's
> great imperial favor.
>
> [translation by Howard Rogers]

[Signed] Fu Wangwen, [seals] Fu Wangwen yin, Tingcun.

The patron was likely one of the examiners for the highest-level civil service examinations, held every three years in the capital. While he himself hopes for imperial favor, his description of the candidates working in frenzy in locked rooms, hoping for the peaches and plums of success, is a poignant one.

The painting lacks the self-conscious monumentality of Yuan's best-known, mostly later, works, and its style links it closely to a scroll dated 1723 (*ZGSHT*, I, 3-090). Yuan is said to have been called to court during the Yongzheng reign (1723-35). Such a visit to Beijing would have given him the opportunity to carry out a commission like this for a civil service examiner.

24 LENG MEI (active circa 1703-42)

Nine Egrets

Dated 1725
Hanging scroll, ink and color on silk
222 × 52 cm

Until recently, the authenticity of this hanging scroll might have been dismissed. After all, Leng Mei was noted primarily for court paintings of an historical and ceremonial nature, properly signed and sealed in accordance with academy practice and painted in the meticulous Qing court style. However, new information requires reconsideration of works like this one.

A recent study by Yang Boda has clarified the facts of Leng's life. He had been a student of Jiao Bingzhen before entering the court and was introduced by him to the court. His arrival there dates before 1703 when his imperially commissioned copy of Qiu Ying's *Spring Dawn in the Han Palace* was completed, and he produced several major works before the end of the Kangxi reign in 1722. Yang points out, however, that archival records do not list Leng's name as an academy painter during Yongzheng, and no reliable extant works from that reign (1723-35) have his signature with the *chen* character ('your servitor,' an expression consistently used for imperial commissions). Leng's album in the Palace Museum collection, *Nongjia Gushi*, is simply signed 'Jinmen huashi Leng Mei hua,' (painted by Leng Mei, painting master from Jinmen), the same signature used here. Based on archival records, Yang has shown that during the first year of the Qianlong reign (1736), Leng again entered the court academy and remained active there through the seventh year of the reign (1742), producing some fifty or sixty major works in the genres of figures, Buddhist and Daoist subjects, birds and animals, horses and dragons, and architectural and historical scenes. These works were often done in collaboration with other court artists, perhaps even including his son, Leng Jian.

Thus we know that Leng spent thirteen years of his maturity outside the court. During this time he most likely would have supported himself by painting for private patrons. For such commissions, less demanding themes would have been appropriate. With his command of academic painting techniques and his familiarity with old paintings in the palace collection, he certainly had the artistic means to paint birds and flowers in the academic style which had originated during the Northern Song and had evolved through the Ming dynasty, later to be revived during the Qing both for popular consumption and for the court.

Leng inscribed his brief dedicatory remarks:

Painted for the comments of master Ziweng in the first month of spring of the *yisi* year [1725] of the Yongzheng reign. [Signed] Jinmen Huashi, Leng Mei, [artist's seals] Lengmei zi Jichen yin, Jinmen Huashi.

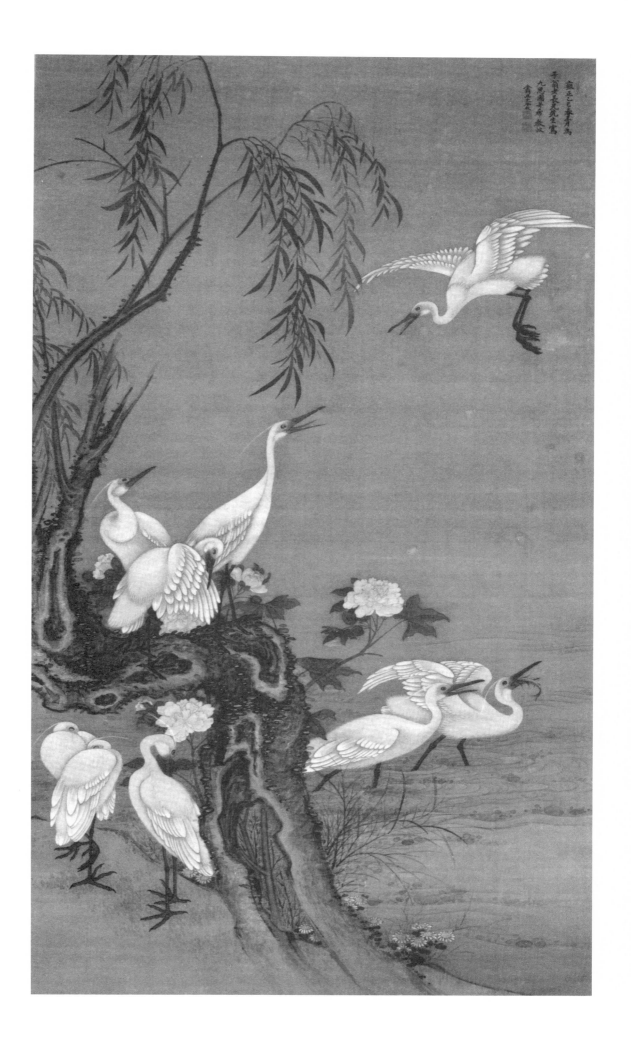

25 LAN HUI (active late 17th - early 18th century)

Landscape after Jing Hao

Dated 1726
Fan, ink and color on gold paper
16.5 × 51.5 cm

Lan Hui's biographical data is scanty and his surviving paintings are equally limited. The most enigmatic of the Lans, his relationship to the better known members of the family is uncertain. One recent source (*ZMRC*, 1492) considers Lan Ying to be his *zhushu*, a kinsman of the parental generation. However, this is contradicted by the fact that, like Lan Ying's grandchildren Lan Shen and Lan Tao, his name Hui bears a water radical, and thus all are likely to be of the same generation. Indeed, a late edition of *Hangzhou Fuzhi* considers him the brother of Lan Shen and Lan Tao, but mistook the three of them for Lan Ying's sons. To set the matter straight, we must place greater faith in *Tuhui Baojian Xuzhuan*, which was likely authored by Feng Ti, a disciple of Lan Ying, and was edited by Lan Ying. Significantly, it mentions Lan Shen and Lan Tao as brothers and puts them together in one entry, while placing Lan Hui further down in a separate entry. The implication is clear: while Lan Hui may be a relation, he probably was not their brother.

The generational uncertainties notwithstanding, it is known that Lan Hui studied Lan Ying's art and focused on the late style of the master. In the present fan, the rendering of trees, rocks, figure, and pavilions, as well as the color scheme, are in keeping with the mature Lan Ying [8]. Though small in format, the fan evokes a breadth of vista while the colors resonate against a golden backdrop.

Lan Hui inscribed the fan:

Emulating the style of Jing Hao at Xishuang Studio at Changan [Beijing] in the chrysanthemum month [ninth lunar month] of the *bingwu* year [1726]. [Signed] Lan Hui, [artist's seal] Lan Hui.

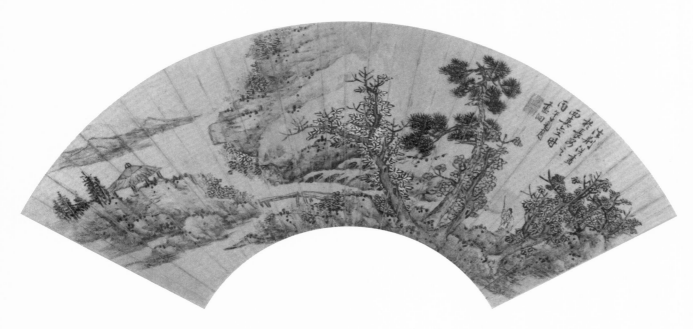

26 DONG BANGDA (1699-1769)

Landscape

Fan, ink and color on paper
23 × 61 cm

Linked by later critics to a hierarchy of orthodox style called the 'three Dong' (that is, Dong Yuan, Dong Qichang and Dong Bangda), this eighteenth-century scholar-artist reached the height of achievement in political office and as courtier-painter to the Qianlong emperor (see Brown in *Elegant Brush*, 84). The catalogs of the Qianlong imperial collection are peppered with references to his paintings: more than 120 works, many of these large sets of scrolls or albums, are recorded in the *Shiqu Baoji* and its sequels.

Dong's dual role at court was not unusual under Qianlong. Not only were the diverse talents of individuals fully utilized but scholar-official painters and calligraphers often collaborated. The present fan, painted for the emperor, results from the collaboration of Dong with Wang Youdun (1692-1758), who served as Grand Councilor from 1745 to 1758 and as editor of the emperor's prodigious output of poetry. Wang's Tang poem written in clerical script might properly be seen as the obverse rather than the reverse of this fan.

The inscriptions on the fan reflect court conventions. The painting is signed:

Respectfully painted by your servitor, Dong Bangda,
[artist's seals] Chen Bangda, Gong hui.

The calligraphy is similarly signed:

Respectfully written by your servitor, Wang Youdun,
[artist's seals] Chen Youdun, Jing shu.

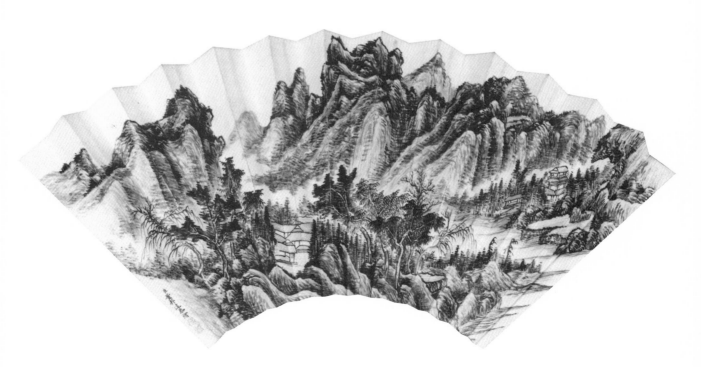

27 ZHANG ZONGCANG (1686-1756)

Landscape after Wu Zhen

Dated 1735
Handscroll, ink on paper
19.4 × 185 cm

In 1751 Zhang Zongcang, already a noted painter in his native region of Suzhou, was recruited for court service by the Qianlong emperor after Zhang had presented him with a series of views of Suzhou on the emperor's southern inspection tour (Yang Xin in *Elegant Brush*, 345; for discussion of Zhang's painting style, see Li, 157-160). Despite the scholar-painter's traditional reluctance to work on commission, service at court was clearly, for Zhang at least, a form of patronage to be actively sought. Although he remained at court only a few years, his output of paintings, as recorded in the imperial catalogs, was extraordinary. Of these more than fifty works survive in the National Palace Museum collection in Taipei (see She Ch'eng in *Elegant Brush*, 329).

This scroll, among the earliest dated paintings recorded for Zhang, shows the artist's experimental combination of the layered dry-brushwork he learned from his teacher Huang Ding (1660-1730), who was in turn a pupil of Wang Yuanqi (1642-1715), with the dark, wet dots of the Wu Zhen manner. Zhang inscribed this scroll as follows:

> My family collected a small handscroll by Meihua Daoren [Wu Zhen, 1280-1354]. In the autumn, lacking any pressing business, I painted this scroll following its general idea. In the year *yimao* [1735], in the early part of the ninth month, [signed] Zhang Zongcang, [artist's seals] Zhang, Zongcang.

Two additional seals, of unidentified collectors, appear on the painting, and three more on the appended section with two colophons, dated 1755 and 1796. Eight more collectors' seals appear on the mounting.

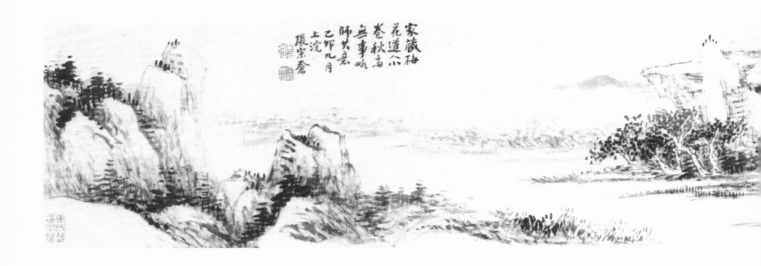

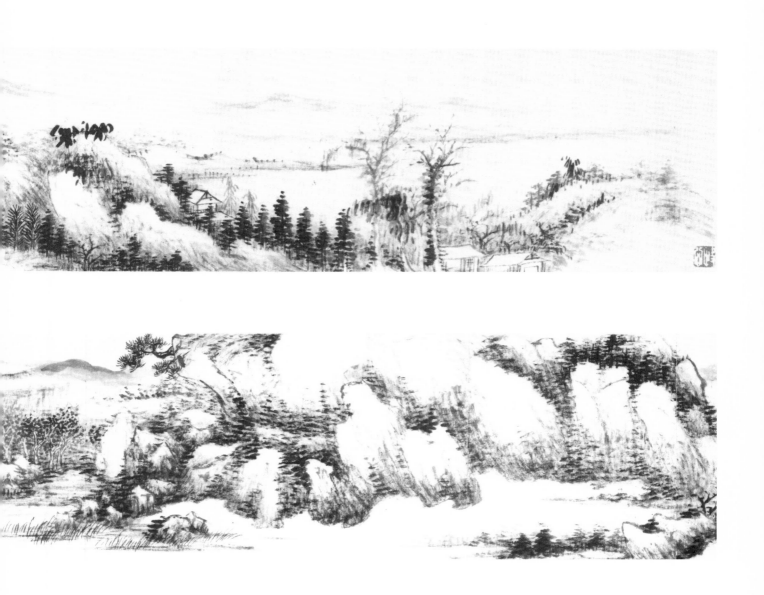

28 ZHANG PENGCHONG (1688-1745)

Landscape: Brush Marks in Blue and Green

Handscroll, ink and color on paper
21.9 × 135 cm

Noted for his literary work, Zhang Pengchong received his *jinshi* in 1727 and entered the Hanlin academy, serving the inner court during the early years of Qianlong. His paintings received the attention of the young connoisseur-emperor, and six of his works were chosen for inclusion in the *Shiqu Baoji* catalogue of the imperial painting collection completed in 1745. Of these two were listed in the *shang* or superior category, perhaps because the emperor had already favored them with his inscriptions. Both of these works were painted in color as well as ink. Although most of Zhang's works published in recent times are monochrome ink paintings, color must have played a significant role in his work. On this blue-and-green landscape, Zhang inscribed his comments on the use of malachite and azurite pigments:

> The Song masters' method of using mineral blue and green colors was truly mastered only by Shitian [Shen Zhou, 1427-1509]. On a leisurely autumn day, I am casually following this idea and wonder what my friend Muweng thinks about it. [Signed] Zhang Pengchong, [artist's seal] Pengchong.

Zhang is probably referring to the integration of the mineral pigments with ragged ink contours and texture strokes as opposed to the application of thick colors within fine outlines where the ink brushwork plays little part.

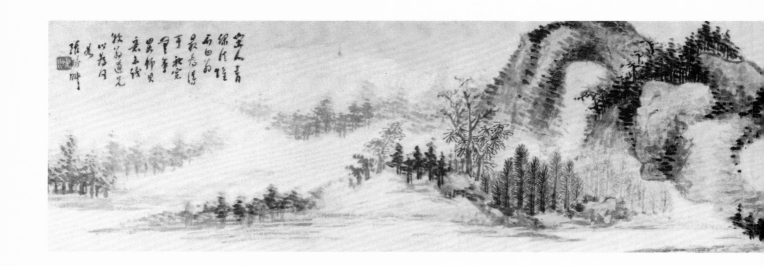

Fourteen years after Zhang's death, Qian Chenchun (1686-1774) wrote the frontispiece for the scroll. Qian (see Fang Chao-ying, in *ECCP*, 146-147) was a son of the noted woman-painter Chen Shu, and would have known Zhang at court. Zhang's friend or patron Muweng is unidentified. One collector's seal appears on the painting.

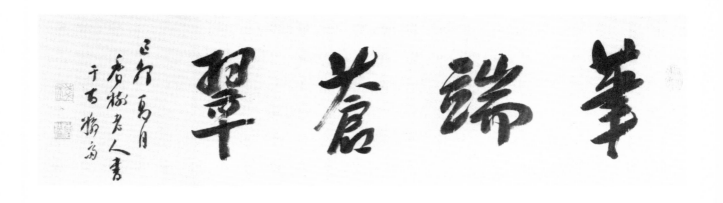

29 YUAN YAO (active circa 1720-80)

Autumn Harvest in a Mountain Village

Dated 1752

Hanging scroll, ink and color on silk

144.9 × 72.3 cm

Yuan Yao, son or nephew of Yuan Jiang [23], perpetuated his elder's style, finding ample patronage from the residents of Yangzhou. Although remaining within the school style, Yuan Yao exhibited scholarly interests (Chou, *Elegant Brush*, 117-118) which gave his accessible and nostalgic landscapes an occasionally literary tone.

Remarkable here is Yuan's detailed account of harvest activities at a large and well-equiped farmstead. At left, oxen pull stone rollers over the threshing floor, while at lower left harvesters gather more grain, and at right water-powered machinery aids a servant in his chores. In the courtyard a woman feeds chickens and another tends the children while the lady of the house drinks tea. The older man observing the threshing operation may be the head of the household. All this is rendered in Yuan's lively figure style and framed by his conventional mountain forms drawn ultimately from Northern Song models. The small group of travelers at the far right is a stock motif of the Yuan School.

This scroll stands apart from much of Yuan's oeuvre in its straightforward description of agricultural industries within a subdued, if still monumental, landscape setting. A similar but smaller, unsigned scroll by Yuan Yao survives in the Palace Museum collection, Beijing (*Paintings by Yangzhou Artists*, no. 24), forming a spring-time counterpart in its depiction of a farmstead and wheat fields in spring.

Published: *Elegant Brush*, no. 39; Harada Bizan, 340.

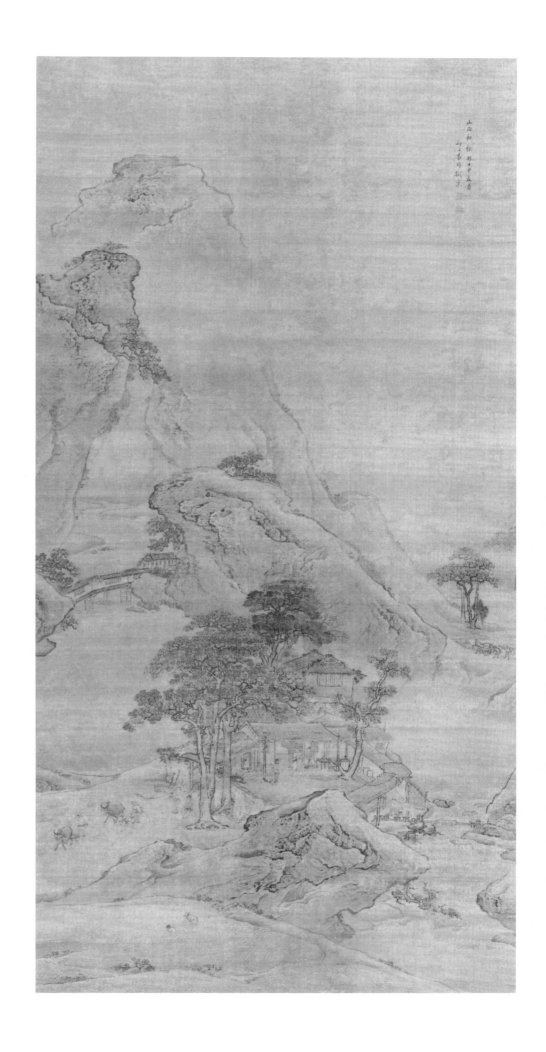

30 HUANG ZHEN (active circa 1732-77)

Landscape

Dated 1777
Hanging scroll, ink and light color on paper
132.6 × 71.6 cm

Huang Zhen was a native of Yangzhou and came to artistic maturity in the art world nurtured by that city's wealthy merchants (see Li Dou, *Yangzhou Huafang Lu*, 751). As early as 1732, he painted the background for a commissioned portrait of one such Yangzhou patron (*Portrait of the Master of the Tonghua Retreat*, figure by Ding Gao, for which see Xu Bangda, pl. 583) in a collaborative effort to which the well-known artist Hua Yan, then visiting from Hangzhou, added a crane.

About the same time, Huang became familiar with the painter Fang Shishu (1692-1751), who had come to Yangzhou from Anhui province. No doubt Fang had brought his Anhui heritage with him, but soon after arriving in Yangzhou he had studied painting with the orthodox master Huang Ding (1660-1730), himself a pupil of Wang Yuanqi. Both lineages show themselves here: the crisp and delicate layering of parallel and sometimes angular land masses reflect a kinship with such Anhui masters as Xiao Yuncong (1596-1674) and the denseness of the composition and the softly dotted brushwork of vegetation suggest the richer, more monumental orthodox tradition. The present work seems to share a palette with works of the seventeenth-century Anhui School, including paintings by Xiao Yuncong (see Cahill, *Shadows of Mt Huang*, 8-9). Pale, warm shades of ink set the tone, their importance heightened by dabs of wash which serve to model the facets of landscape forms.

Huang signed the painting:

Painted by Huang Zhen, [called] Zhengchuan, during the last ten days of the ninth lunar month of the *dingyou* year of the Qianlong reign [1777]. [Artist's seal] Huang Zhen.

Published: Suzuki, JP14-158

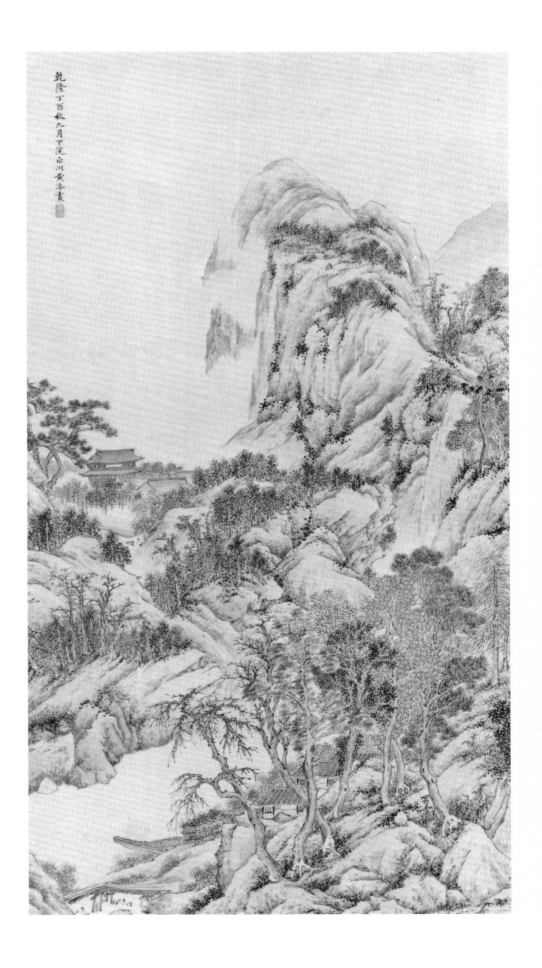

乾隆丁酉秋九月下澣巴川黃喬畫

31 WANG CHEN (1720-97)

Landscapes: Ink Play

Dated 1791
Album of 8 leaves, ink on paper
Each leaf 24.2 × 29.8 cm

A great-grandson of Wang Yuanqi (1642-1715), who was in turn descended from Wang Shimin (1592-1680), and a student of Dong Bangda [26], Wang Chen could hardly have been more steeped in the tradition of the Orthodox School of painting. He was so much associated with the style that critics linked his name with those of three other descendants of Wang Yuanqi and Wang Hui to form the Four Lesser Wang. Wang Chen served in several minor official posts, the last of which was as prefect of Yongzhou [now Lingling] in Hunan province. Although politically minor, the post had some bearing on his artistic career for it brought him to an area of scenic beauty and historical associations near the confluence of the Xiao and Xiang rivers (see Chou, in *Elegant Brush*, 66).

Painted in the year after his retirement from public office, this album reiterates Wang's longstanding interest in the old masters, showing greater ease and confidence than his 1782 album of twelve leaves following the styles of Song and Yuan masters (see *Paintings of the Ming and Qing Dynasties*, no. 77). In this later work, Wang adds late Ming and early Qing artists Dong Qichang and Wu Li to his models and eliminates the Song masters. In instances where his models are the same, the leaves in the later album are recast from the compositions of the first: landscape elements are simplified and made bolder and the brushwork is more thoroughly and consistently his own. Now in his seventies, the artist appears to have come to terms with his orthodox heritage, having solved the question of how one can work within a conventional manner to create a work of freshness and subtle individuality.

Published: *Elegant Brush*, 66-68.

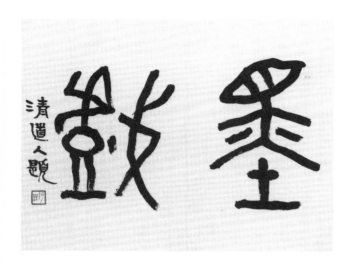

A frontispiece with the title *Mo Xi* ('Ink Play') was written for
the album by the calligrapher Li Ruiqing (1867-1920).

Leaf A

In the style of Cao Yunxi [Cao Zhibo]. [Artist's seal] Wang
Chen zhi yin.

Leaf B

In the manner of the venerable Songxue [Zhao Mengfu].
[Artist's seal] Xiaoxiang weng.

Leaf C

After Dachi [Huang Gongwang].
[Artist's seal] Pengxin hanmo.

Leaf D

After Ni Gaoshi [Ni Zan]. [Artist's seal] Zining.

Leaf E

After a genuine work by Huanghe Shanqiao [Wang Meng].
[Artist's seal] Zibing.

Leaf F

This too aims to capture [the spirit of] Ni Yunlin [Ni Zan].
[Artist's seal] Wang Chen zhi yin.

Leaf G

In the manner of *Bamboo Groves in Autumn Hills* by Mojing
Daoren [Wu Li]. [Artist's seal] Wang Chen zhi yin.

Leaf H

After Dong Wenmin [Dong Qichang]. In the eighth month of
the *xinhai* year [1791], for the honorable Yuqi. [Signed] the
retired prefect of Xiaoxiang, Wang Chen, at seventy-two *sui*,
[artist's seals] Chen Yin, Zining.

A colophon dated 1920, written by Tao Jianqiu, is appended
to the album.

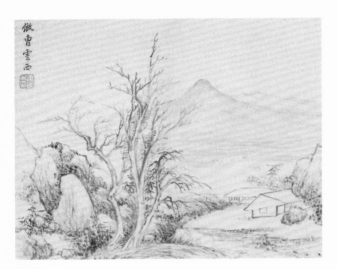

Leaf A

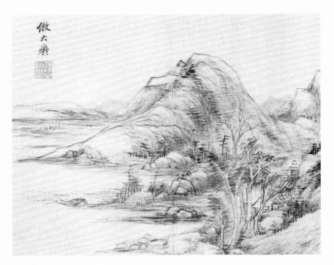

Leaf C

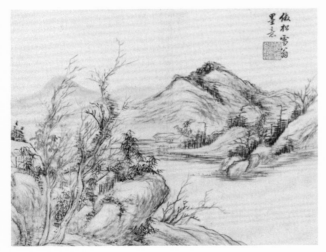

Leaf B

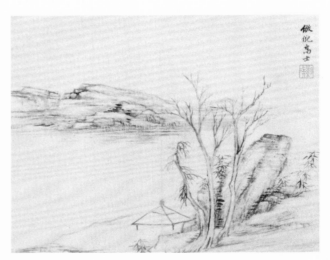

Leaf D

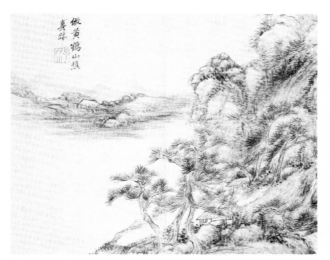

Leaf E

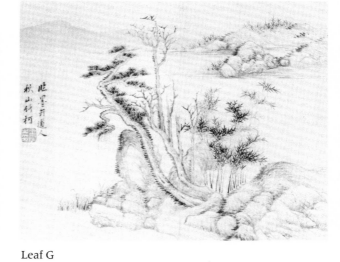

Leaf G

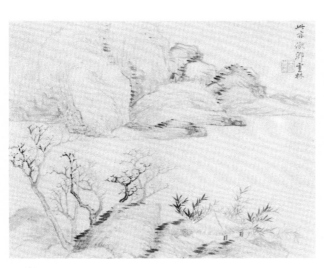

Leaf F

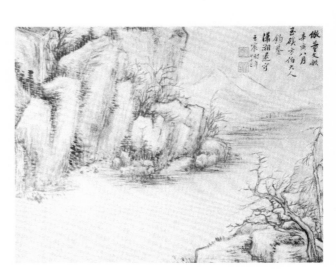

Leaf H

32 QIAN WEIQIAO (1739-1806)

Landscape: The Xiangsu Thatched Hut

Dated 1788
Handscroll, ink on paper
26.7 × 109.3 cm

As so often happens in the case of younger members of a famous family, Qian Weiqiao's biography often seems appended as an afterthought to that of his elder and better-known brother, Qian Weicheng (1720-72), who served at court as high official and painter. (For Qian Weicheng, see Brown, in *Elegant Brush*, 78-83; and Tu Lien-che, *ECCP*, 158). Qian Weiqiao was a painter, a poet, a dramatist and a minor official. Qian Weicheng's junior by nineteen years, he was too young to have known his grandmother, the highly respected flower and landscape painter Chen Shu, who died in 1736. Whether the younger brother had any lessons in painting from the elder, whose service in Beijing began as early as 1742, is not clear.

Muted dabs of ink on absorbent paper characterize this landscape and link it to other works by Qian (particularly an album of 1783; see *Qian Zhuchu Shanshui Jingpin*), all of which fall generally within the style of the Loudong School of Wang Yuanqi's followers. Qian's inscription here strikes a casual note:

> Lanxue was about to move to Sushan and asked me to paint this picture of the Thatched
> Hut at Sushan. I am not skilled in painting, but painted this without trying very hard. In
> the future, I shall compose a set of ten poems to celebrate the thatched cottage. In the
> *wushen* year of the Qianlong era [1788], ninth month, second day, [signed] Qian Weiqiao,
> [artist's seals] Zhuchu, Huayin.

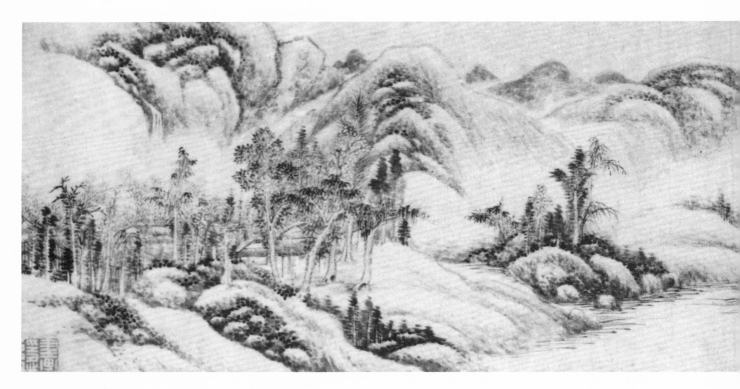

Lanxue, Wu Songliang (1766-1834), was a disciple of the scholar-official Weng Fanggang (1733-1818), whose colophon dated 1789 is appended to the scroll. A frontispiece, 'Xiangsu Thatched Hut,' was written by Qian Daxin (1728-1804). At the time he painted this landscape, Qian Weiqiao was serving as magistrate in the port city of Ningbo. In the same year, he invited Qian Daxin to compile the local history of the region (see Tu Lien-che, in *ECCP*, 152-155). Qian Daxin most likely wrote the frontispiece sometime during his months of workn the Ningbo area.

Following the inscription by Weng Fanggang are colophons by Shishi Yong-guang, Kang Lunjun, Gan Zhiji, Wang Li, Chen Lanxiang, Li Chuanjie, Wang Duanguang, Zhou Houyuan, Shu Menglan, He Weipu, and Luo Zhenyu.

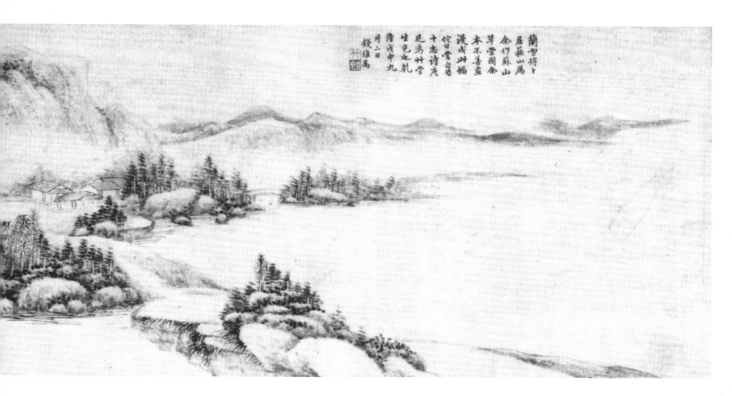

33 WAN SHANGLIN (1739-1813)

Travelers Among Streams and Mountains

Dated 1808
Hanging scroll, ink and color on silk
191 × 100.5 cm

Wan Shanglin, from Nanchang in Jiangxi province, has been noted for his freely sketched ink paintings, including works in the manner of Ni Zan (see Ellsworth, I, 2 and 74) and plum blossoms painted with the finger tips (see *ZGSHT*, I, 9-202 and 11-124). However, several of his surviving and recorded landscapes were painted in colors, often in the blue-green mode (for extant paintings, see *ZGSHT*, I, 2-635; Ecke, *Wen-jen Hua*, no. 35).

Although Wan probably intended to impart a Tang flavor to his landscape, his painting is an amalgam of various past styles. While the composition derives from Northern Song monumental landscapes, the brushwork and application of color resemble Yuan dynasty blue-and-green paintings. An underlying structure of ink drawing and texture strokes fully delineates the landscape while overlaying malachite and azurite pigments lend a nostalgic tone but at the same time an illusionistic immediacy. Wan's familiarity with paintings by Song and Yuan artists who worked in the blue-and-green manner is confirmed by a record of an album dated 1795 in which he copied among other models Zhao Boju (died circa 1162) and Zhao Mengfu (1254-1322). The subject matter recalls the Northern Song theme of travellers in a mountain wilderness, and also evokes narratives linked to an earlier era. The artist's inscription is terse:

> Early autumn of the *wuchen* year [1808] of the Jiaqing reign, Wan Shanglin [called] Wanggang. [Artist's seals] Wan, Wanggang shuhua.

Published: Siren, VII, 419; Guo Weiqu, *Song Yuan Ming Qing Shuhuajia Nianbiao*, 428; *Shina Meigashu*, 84.

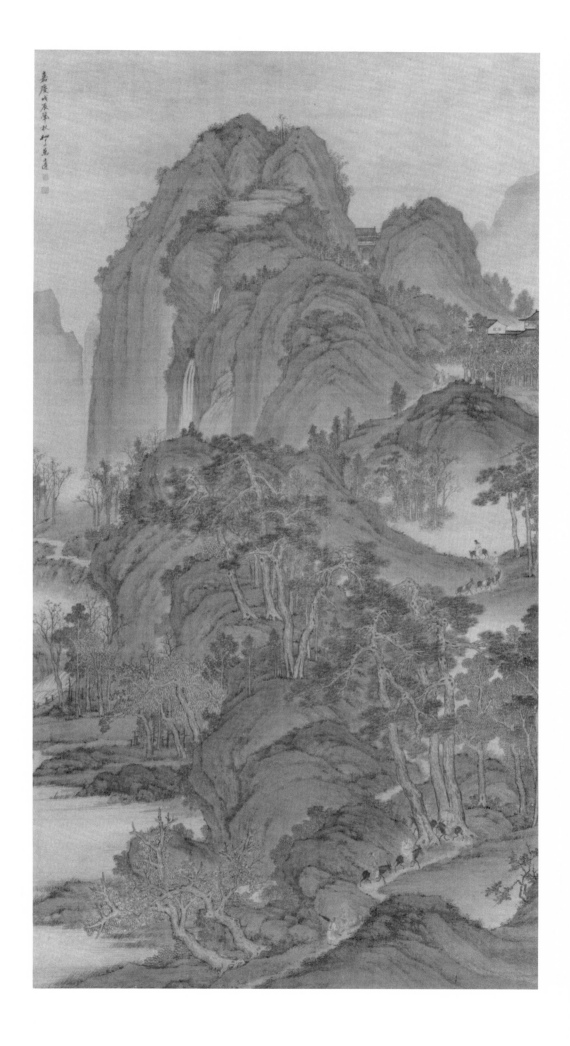

34 QIAN FENG (1740-95)

Ten Thousand Pines

Dated 1782
Hanging scroll, ink on paper
109.2 × 34.3 cm

The censor Qian Feng painted *Ten Thousand Pines* within a few months after his courageous prosecution of Guo Tai and Yu Yijian, two henchmen of the notorious corrupt official Heshen. Although Qian received promotion and imperial protection, his position remained precarious until his death three years later. The Taoist sentiment of Qian's inscription may reflect his satisfaction with his daring stand against the powerful and corrupt clique:

> To meditate on the secret of 'keeping to the dark,'
> I finished the *Huangting*, becoming free for the rest of the day.
> I walked out the door to follow my whim;
> A sustained shout rose from amidst the ten thousand pines.

> [translation by Ju-hsi Chou]

The concept of 'keeping to the dark' stems from a passage in *Laozi*, and may here have reflected Qian's avoidance of the easy lure of corruption. (For a full discussion of Qian's biography and full translation and analysis of the three inscriptions on the painting, see Chou, in *Elegant Brush*, 103-4. For further discussion of the political circumstances see Knight Biggerstaff, in *ECCP*, 150-51.)

Although well-known as a calligrapher, Qian is not so often encountered as a painter. Extant works are mostly paintings of horses, a theme which he, like the Yuan scholar-painters before him, may have used for its political symbolism. His few surviving landscapes show him to have created a distinctive individual style. As Chou has pointed out, Qian's father was a silversmith, and his crisp and delicate landscape style seems to reflect the precision of that craft. Even the dry ink applied in trees and landscape forms has a silvery allure. Ultimately, however, the landscape stems from late Wu School painting, and reminds one of the work of an official of the previous generation, Li Shizhuo (circa 1690-1770). None of these sources, however, accounts for the marked use of shading to emphasize the abstract, structural masses in the painting, disturbing accents in an otherwise placid composition.

Published: Siren, VII, 308; *Elegant Brush*, 103-5.

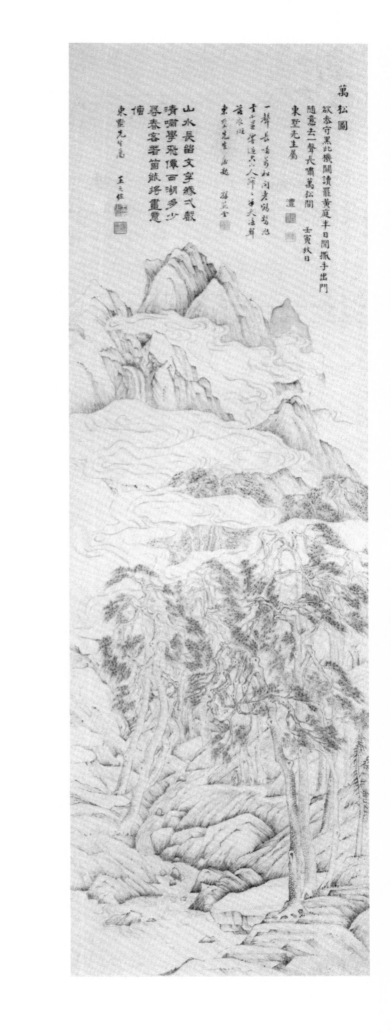

萬松圖

欲奏守黑此機閒讀罷黃庭半日閒振手出門
隨意去一聲長嘯萬松閒　壬寅秋日
東墅先生為

一聲長嘯萬松閒同老鳩蹈龜
書山窩道光八年上浣大滿年
青原城
東墅先生為題　孫茶谷

山水長留文字縁式觀
清嘯學飛僊西湖多少
尋春客莫笛能將畫意
傳
東墅先生屬　王之佐

35 WANG XUEHAO (1754-1832)

Landscapes: Spurred on through Misty Clouds

Dated 1817
Album of 12 leaves, ink or ink and color on paper
Each leaf 25.3 x 32.2

Wang Xuehao, sometimes grouped with Wang Chen [31] as one of the Four Lesser
Wang, was a third-generation follower of Wang Yuanqi (see Fu and Fu, 336-37). His
ability to wed the technique of the Loudong School with imagery freshly drawn from
art-historical sources, and his application of ink and color with palpable variation and
richness are well displayed in this album of twelve leaves. In his hands, the Orthodox
tradition becomes a foundation for lively brushwork and bright contrasts.

Wang's inscribed dedication on the last leaf indicates that the album was done
for Mr. Jie'an, unidentified, and that the leaves were painted during winter of the
bingzi year (late 1816 to early 1817) and spring of the *dingchou* year (1817).

Published: Moss, 112-26.

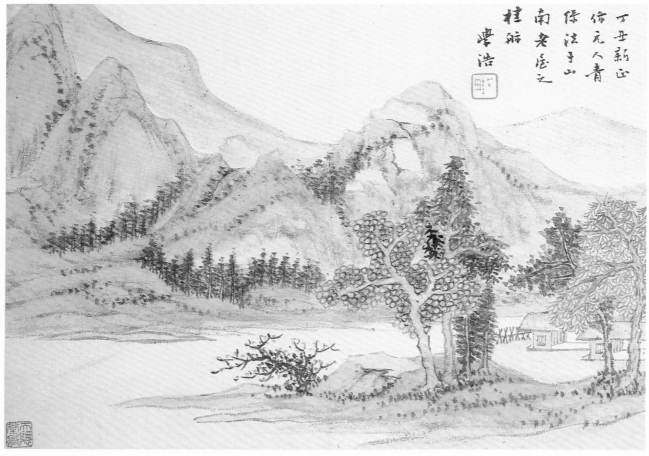

Leaf B

Frontispiece
Spurred on through Misty Clouds, [signed]
Jiaoqi inscribed for himself, [artist's seals] Bu qiu si,
Wang Xuehao yin.

Leaf A
In the twelfth month of the *bingzi* year [1817], plum blossoms
longing to bloom, [I] used the method of Yingqiu [Li Cheng]
to paint the theme of *Searching for Plum Blossoms*. [Signed]
Jiaoqi Hao, [artist's seal] Wang Xuehao yin.

Leaf B
In the first month of the *dingzhou* year [1817], [painted]
after the Yuan painters' blue-and-green method, at
the Cassia Boat of Shannan Laowu. [Signed] Xuehao,
[artist's seal] Jiaoqi.

Leaf C
The style of Qingbi [Ni Zan] has been transmitted for
 generations;
Spring in Pucheng is paled by the mist.
I pluck flowers to draw a smile from Vimalakirti,
If this is not the Zen of poetry, it certainly is the Zen
 of painting!

In the first month of the *dingzhou* year, after the style
of Yunlin [Ni Zan], [signed] Jiaoqi, [artist's seal] Wang
Xuehao yin.

Leaf D
Imitating the ink style of Meihua An [Wu Zhen]. [Signed]
Xuehao, [artist's seal] Jiaoqi.

Leaf E
The greater Mi's [Mi Fei's] cloudy mountains represent a
form of ink play; the most difficult thing is to go beyond the
brush and ink. In the first month of the *dingzhou* year [1817],
experimenting with my brush, [signed] Jiaoqi, [artist's seal]
Wang Xuehao yin.

Leaf F
My imitation of the Yuan masters' idea, [painted] at the
Resting-in-the-Mountains Pavilion of Shannan Laowu.
[Signed] Jiaoqi, [artist's seal] Wang Xuehao yin.

Leaf G
Imitating Dachi [Huang Gongwang], [painted] at Shannan
Laowu. [Signed] Hao, [artist's seal] Jiaoqi.

Leaf H
'Marquis Wang's strength of brushwork can lift a bronze
ding; for five hundred years now we haven't had such a man.'
This is the couplet that Yunlin [Ni Zan] offered Huanghao
Shanqiao [Wang Meng]. I just happen to imitate his idea and
write it down. [Signed] Xuehao, [artist's seal] Jiaoqi.

Leaf I
Who is he that consigns his fate
To the mournful whistling through a handful of leaves?

Imitating the idea of old Shitian [Shen Zhou], [signed]
Jiaoqi, Hao [artist's seal] Jiaoqi.

Leaf J
Imitating the style of Dachi [Huang Gongwang], [signed]
Xuehao, [artist's seal] Jiaoqi.

Leaf K
I wanted to follow the style of Gao Fangshan [Gao Kegong],
but it turned into that of Fang Fanghu [Fang Congyi].
[Signed] Jiaoqi, [artist's seal] Wang Xuehao yin.

Leaf L
After the style of Huichong [active early eleventh century].
In the winter of the *bingzi* year and spring of the *dingzhou* year,
for Mr Jie'an, imitating the various Song and Yuan masters
styles, offered for your correction. [Signed] Wang Xuehao,
[artist's seal] Jiaoqi.

[translations adapted from Moss, 112-126]

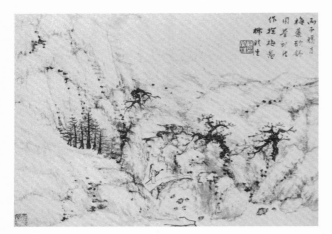

Leaf A

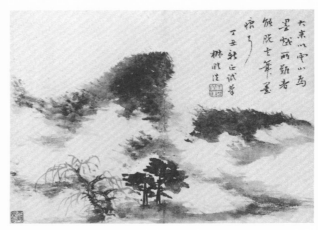

Leaf E

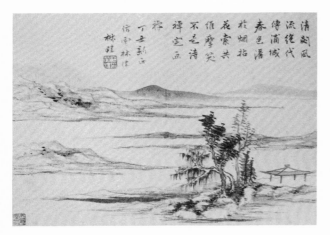

Leaf C

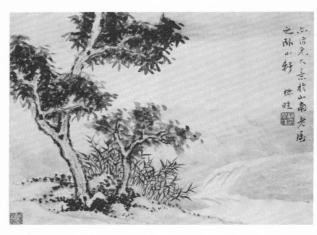

Leaf F

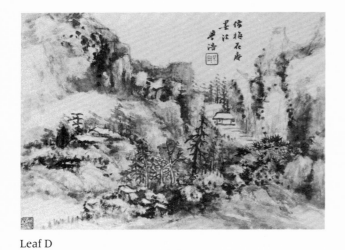

Leaf D

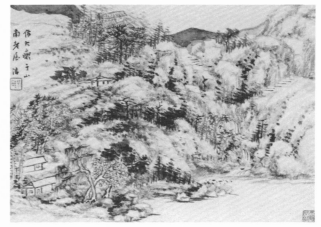

Leaf G

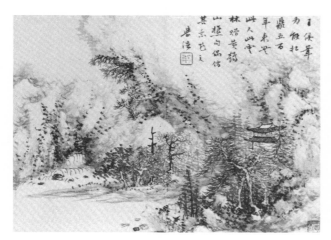

Leaf H

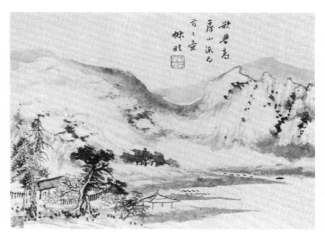

Leaf K

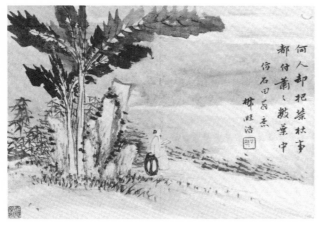

Leaf I

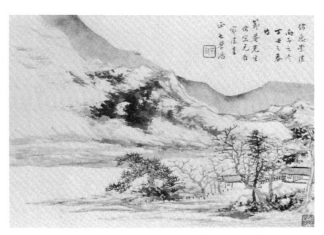

Leaf L

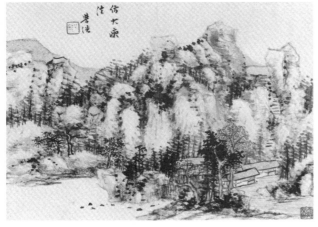

Leaf J

The album includes a postscript written by Wang Zheng
(1867-1938) in 1931. A collector's seal, *Tianyintang cang*,
appears throughout the album.

36 ZHOU KAI (died 1837)

Landscapes

Dated 1819
Album of 8 leaves, ink or ink and color on paper
27 × 25.3 cm

Zhou Kai, from Fuyang in Zhejiang province, earned his *jinshi* degree in 1811. He served in several minor posts, and in his later years held administrative positions in Fujian and Taiwan. His literary work was collected into an anthology for which Wang Xuehao [35] wrote a preface. Standard sources describe his painting style as modelled upon the Yuan and Ming masters, and the inscriptions on the present album would seem to bear this out, for Zhou claims to be following Tang, Song or Yuan masters. However, the style of the album, consistent throughout its eight leaves, is above all beholden to the seventeenth-century Nanjing School. The paintings of Wang Gai or Fan Qi seem to lie behind these level views in atmospheric mist. A certain bluntness of brushwork and starkness in contrasting ink tones is reminiscent of Dong Gao, who is sometimes cited as Zhou's mentor (see *ZMRC*, 491; on Dong Gao, see Brown, in *Elegant Brush*, 94-5).

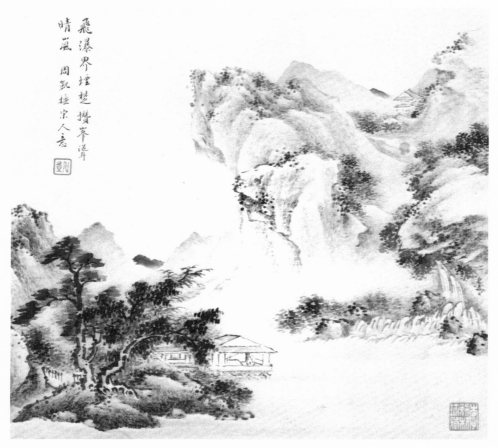

Leaf A

Leaf A

A descending waterfall divides the hidden from the seen.
A row of peaks rises against the clearing haze.

Zhou Kai in emulation of Song painting, [artist's seal] Kai.

Leaf B

In fashioning a pictorial image, one should avoid being sweet and ripe. The compositions of the ancient masters were conceived deep within the heart and through intuitive means. Ordinary people, on the other hand, seek a new outlook in such aspects as the delicate, the eccentric, and the vulgar. I myself harbor [grand] ideas but cannot often realize them in practice. Zhou Kai, [artist's seal] Kai.

Leaf C

In times of adversity, it's best to return to farming.
Sleeves full of empty air, one may pretend to be a free spirit.
In this world, where hundreds of commodities double
 in price,
It costs nothing to view the hills beyond.

Zhou Kai in the *xieyi* mode, [artist's seal] Kai.

Leaf D

The Yuan artist Zhang Boyu [Zhang Yu] commented on paintings by Yifeng Laoren [Huang Gongwang] saying that his mountains, hillocks and valleys are integrated and substantial, so much so that they are formed as if by heavenly forces. Only Loutai [Wang Yuanqi] could obtain this divine resonance. No one else could attain that. [Signed] Zhou Kai, [artist's seal] Zhou.

Leaf E

Spanning the Wu and Chu,
The river merges with the sky.
At dusk, countless sails slowed to a halt, fearful of the [hidden] boulders.
[People from] the mooring ships eagerly sought news from
 the willow-lined shore.

Zhou Kai, after a Yuan master's idea, [artist's seals] Zhou, Kai.

Leaf F

In painting *Moist Greenery and Floating Mist*, I am learning
 from Dachi [Huang Gongwang].
Focusing on landscape, I let the floral season pass.
Harbor no fear of storm and waves ahead,
For in this small boat the spring brightens and poetry arises.

Zhou Kai sketching the general tone of a Tang poem,
[artist's seals] Zhou, Kai.

Leaf G

The tall cliffs float in an azure void.
A stretch of woods locks in the chilling mist.

Zhou Kai emulating the ancients, [artist's seal] Zhou.

Leaf H

Clearing Snow over Streams and Hills. In the third month of the *jimao* year [1819], Zhou Kai, [artist's seal] Zhou.

[translation by Ju-hsi Chou]

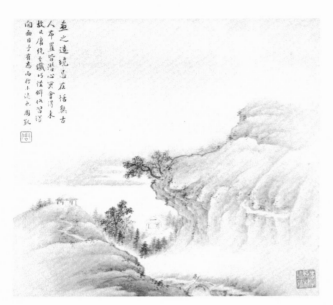

Leaf B

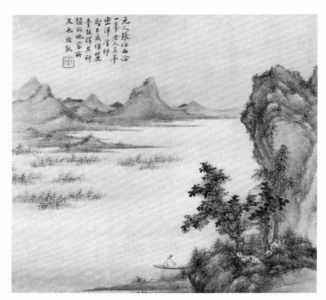

Leaf D

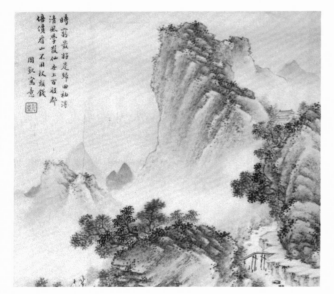

Leaf C

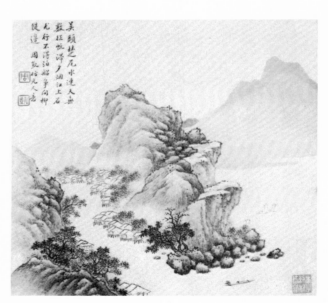

Leaf E

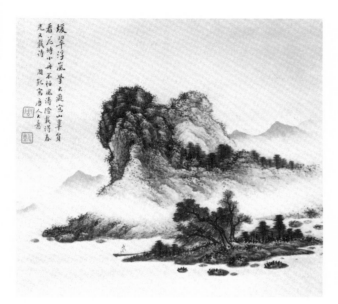

Leaf F

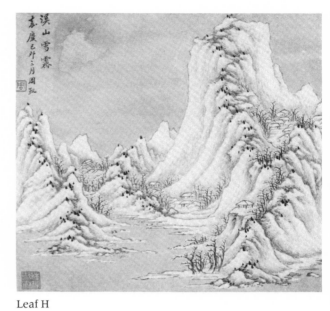

Leaf H

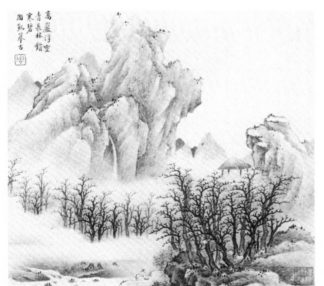

Leaf G

37 ZHU HAONIAN (1760-1834)

Landscape after Shen Zhou

Dated 1813
Hanging scroll, ink and color on paper
119 × 27 cm

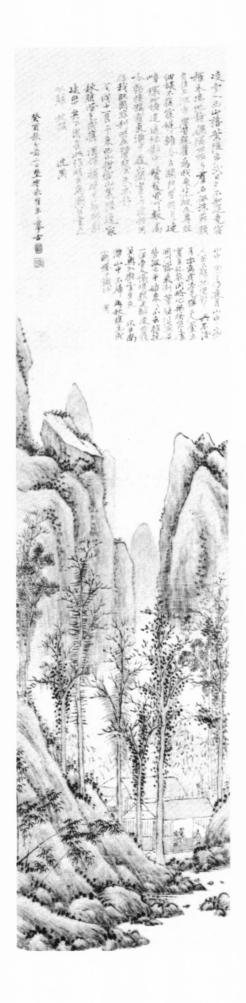

From Taizhou, Jiangsu province, Zhu Haonian lived in Beijing. Although he took the seventeenth-century individualist painter Shitao as his principal model in painting, here Zhu imitated the earlier Ming artist Shen Zhou (1427-1509), making a close copy of a painting he had probably seen in a private collection. Although the model has not been identified among recorded or extant works, its date of 1478, based on a cyclical year mentioned in the long inscription which Zhu seems to have copied verbatim, confirms that it was an early work by Shen, and the composition with its sharply rising peaks to either side of the cottage suggests a similarity to Shen's well-known work in the National Palace Museum, *Night Vigil*, dated 1492 (see *Ninety Years of Wu School Painting*, no. 002).

Zhu's work is dated 1813, and aside from inscribing the original texts by Shen Zhou, Zhu wrote:

Imitating an ancient style, two days before the autumn equinox of the *guiyou* year [1813]. [Signed] Yeyun Zhu Haonian, [artist's seals] Hao, Yeyun.

The interest of Qian Du and Zhang Yin in the Wu School style is well established. Zhu's painting further documents the importance of this Suzhou manner to artists in the first half of the nineteenth century.

38 ZHANG YIN (1761-1829)

Landscape in Blue and Gold: Returning by Oar to Pines and Streams

Dated 1807

Hanging scroll, ink and color on silk

157 × 94 cm

Among nineteenth-century painters, Zhang Yin, from Dantu in Jiangsu province, was foremost in reviving the robust and direct, and often patternized, brushwork of Shen Zhou, and the crisp linearity of Wen Zhengming. From these he forged his own manner of linear patterns, used innovatively to impart almost a 'pointillist' aspect to much of his work. Here, however, he clearly was aiming for a more antique effect, and thus chose to work in colors and ink on silk. His composition has the straightforward diminution of scale in receding planes and the single, monumental peak of works associated with the tenth and eleventh centuries, particularly with the Juran manner, but his patternized treatment of trees and low vegetation and his self-conscious application of the textural ink brushstrokes set the painting apart from its models. The archaizing manner suits the remoteness of the idealized cottage to which scholars in a boat are returning. Zhang's inscription is cursory:

> *Returning by Oar to Pines and Streams.* Painted by Zhang Yin in the *dingmao* year [1807], summer, the sixth month. [Artist's seals] Zhang Yin zhi yin, Bao yan.

Published: Suzuki, JP14-165

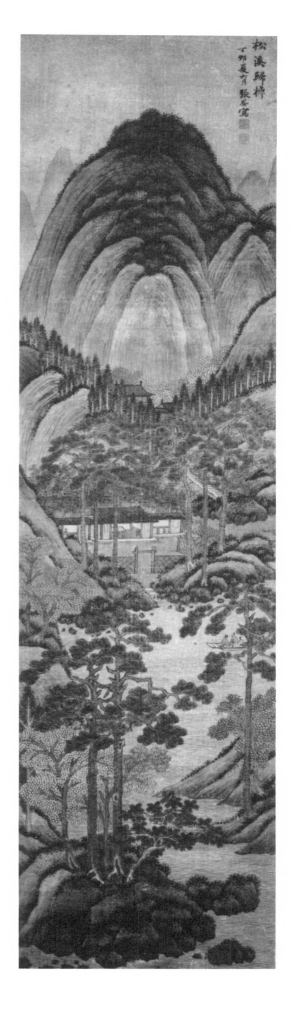

39 WANG SHOU (active nineteenth century)

Landscapes: Tinkling Gems to Excite the Eye

Dated 1817
Album of 12 leaves, ink or ink and color on paper
Each leaf 31.8 × 41.6 cm

While little is recorded of the artist Wang Shou (see *Zhongguo Lidai Shuhua Zhuanke Jia Zihao Suoyin*, *shang*, 1288), from Haiting in Zhejiang province, this – his only known work – shows him to have been well trained in the Orthodox manner and one of many artists who preserved the tradition stemming from Wang Yuanqi into the nineteenth century. His models here include, besides Wang Yuanqi, the great Yuan masters, but his painting style derives from the late eighteenth-century Orthodox manner, notable for its bold compositions and effective use of color.

Given what little is known of Wang's activity, the cyclical date of the album might be read as 1817 or 1877, but the similarity of his work to that of Wang Xuehao, and the remarkable resemblance to Wang Xuehao's album of 1817 in the present exhibition [35], make the earlier dating far more convincing.

Eleven leaves are inscribed by Wang Shou; the last leaf bears the inscription of Zhang Jian, who remains unidentified as does the patron, a master Haiping.

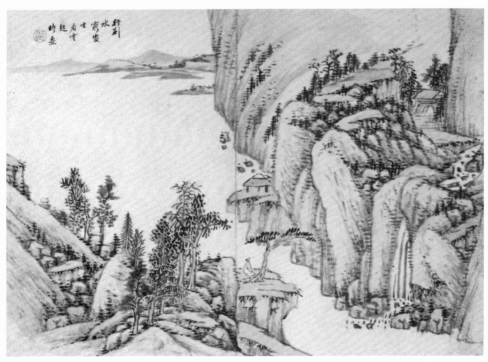

Leaf I

Leaf A

Imitating the brushwork of Yifeng Laoren [Huang Gong-wang], the resemblance [is found] beyond the manipulation of the brush. Does master Haiping agree with me? [Signed] Yungu, Shou, [artist's seals] Wang Shou, Yungu.

Leaf B

The painting method of Meihua Anzhu [Wu Zhen] is superior. His use of brush is bold and elegant. One cannot learn it merely through diligent work. I imitate his style at my leisure by the window, embarrassed [to find] it does not bear any resemblance. [Signed] Yungu Wang Shou, [artist's seals] Wangshi, Shou.

Leaf C

I once saw a genuine work by Wang Sinong [Wang Yuanqi] at a friend's place. His use of color enriched the mountain and the water. His splashes of ink create a luxuriant quality in the vegetation. It is right to call his work 'untrammelled.' In a mountain studio, I freely imitate his style for master Haiping. [Signed] Wang Shou, [artist's seal] Shou.

Leaf D

The lake is peaceful at both shores.
The clouds embrace several peaks.

Painted in the second month, spring of the *dingchou* year at the Small Anya Pavilion of the Longqiu Lodge. [Signed] Wang Shou, [artist's seal] Shou. [One additional seal at lower left, unidentified.]

Leaf E

[Signed] Wang Shou, [artist's seals] Wangshi, Shou.

Leaf F

The sky has just cleared after the snowfall. My studio is spacious inside. Painting this small piece, a pleasant feeling comes over me. [Signed] Yungu Wang Shou, [artist's seals] Wang Shou, Yungu.

Leaf G

Following a transformed style of Ke Jingzhong [Ke Jiusi]. [Signed] Yungu, [artist's seal] Yungu. [One additional seal at lower right, unidentified.]

Leaf H

Views of the Taiheng Mountains. [Signed] In spring of the *dingchou* year, Yungu Shou, [artist's seals] Yun, Gu, Xianfang.

Leaf I

Having walked to the water's edge,
I sit and watch the clouds rise.

[Signed] Shou, [artist's seal] Shou.

Leaf J

Shadows and mist float among tall and short trees,
Diluted ink blurs near and distant mountains.

[Signed] Yungu Shou, [artist's seals] Wangshi, Shou. Additional seal, lower left: Hanmo Taoqing.

Leaf K

The sea shore stretches out at low ebb.
A sail is hoisted in the wind.

[Signed] Wang Shou, [artist's seals] Shou.

Leaf L

[Inscription by Zhang Jian] *Tinkling Gems to Excite the Eyes.* I inscribe the album of elder Wang Yungu at the Longqiu Lodge for the master-poet Haiping in the second month of spring, in the *dingchou* year. [Signed] Zhang Jian, [seal of Zhang Jian] Zhang Jian yin. [Artist's seal] Wang Shou yin.

[translation by Wai-fong Anita Siu]

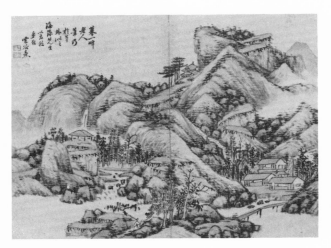

Leaf A

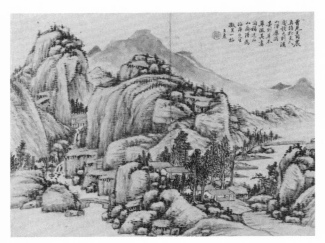

Leaf C

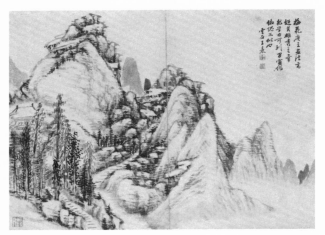

Leaf B

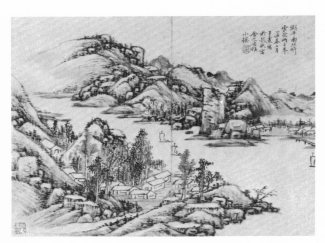

Leaf D

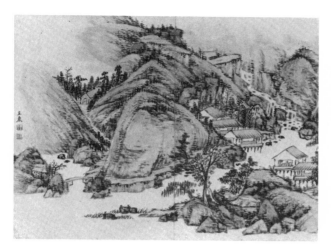

Leaf E

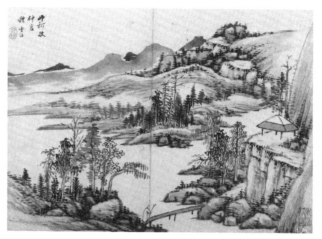

Leaf G

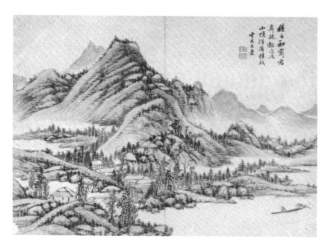

Leaf F

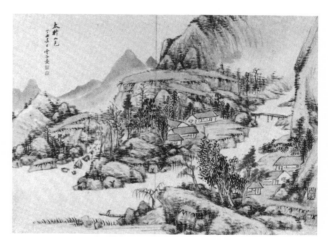

Leaf H

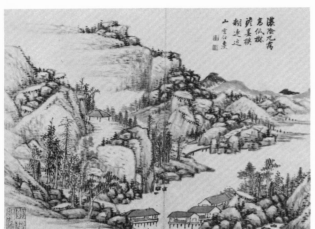

漱潅兀啊
名似槭
渓差模
朝逐近
山雲仍愛
澗龍

Leaf J

湖平
両潤
嶠響
成些
楼王
寫遠

Leaf L

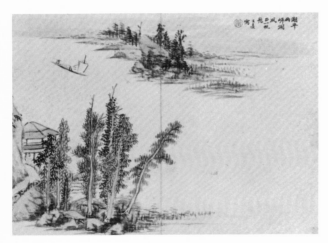

Leaf K

40 QIAN DU (1763-1844), DAI XI (1801-60) and others

Landscapes: The Western Prunus Villa

Album of 8 leaves, ink or ink and color on paper
Each leaf 16.3 × 21.3 cm

This small album contains landscapes by eight artists painted for the patron Shouqiao, possibly identifiable as Ji Nan, from Jiaxing, Zhejiang province. Each leaf provides the artist's idealized portrayal of Shouqiao's retreat, the Western Prunus Villa, painted perhaps when he was enjoying Shouqiao's hospitality.

The album reflects a Jiangnan style which has been noted primarily in the work of Qian Du but which actually was a widespread regional style based on survivals from the late Ming Wu School and the continued fashion for paintings of scenic spots of the Lake Tai region. The eight leaves are painted in the careful manner demanded by the small album format, giving the finished piece the aspect of a miniature. Aside from Qian Du and Dai Xi, the artists are little known, their dates and biographies anything but certain.

Published: *ZMRC*, 941; Jiang Baoling, *Molin Jinhua, juan* 11, 11a.

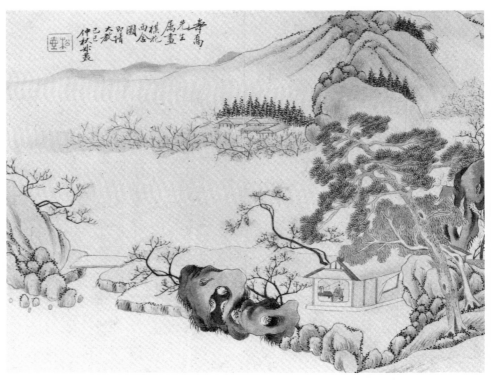

Leaf B

Leaf A

Painted in ink and color by Jiang Hao, and inscribed by him with the poem:

> Looking from a distance, the lake and mountains are
> linked with the hidden villa.
> The snowstorm delights the heart of one who lives in this
> house of longevity.
> Surrounded by prunus blossoms in the chilly weather,
> [One can] read rare books in the small thatched cottage.
> In the moonlight, the flowers are bright as snow.
> Fragrance lingers on the river when spring comes to the
> riverside cottage.
> I wish to buy a mountain to raise bamboo
> And build a thatched studio deep among a
> thousand peaks.
>
> [Signed] Huayin Hao, [artist's seals] Jiang, Hao.

This Jiang Hao may be the late Qianlong-period artist from Jiaxing cited in Yu Jianhua (*ZMRC*, 1361), but a discrepancy in his death date precludes certain identification.

Leaf B

Painted in ink and color by Qian Du, and briefly inscribed:

> A picture of Prunus Villa, painted for the comments of master Shouqiao in the second month of autumn [the eighth month], in the *jisi* year [1809]. [Signed] Shumei, [artist's seal] Songhu.

This early work by Qian already shows his characteristic fine-lined and flatly colored style, together with a serpentine stylization of trees and rocks which may ultimately derive from Yun Shouping (see Fu and Fu, 334-35).

Leaf C

In ink and slight color, painted and inscribed by Dai Xi, who was a generation younger than the other artists involved in the project:

> A bamboo cottage in a secluded spot
> Receives the abundance of spring in this
> uninhabited mountain.
> In my mind, I see an evening cold and moonlit
> And a poet embraced by ten thousand prunus.
>
> In the early spring of the *jiyou* year [1849], painted and inscribed for senior Shouqiao. [Signed] Qiantang Dai Xi, [artist's seal] Chunshi.

Dai Xi's texture strokes have the soft, rubbed appearance characteristic of his style. Even the brushwood fence and the cottage are gently modelled, with contrast added by spiky prunus trees.

Leaf D

Painted in ink and light color by Chen Qian, and briefly inscribed by the artist:

> Picture of the Prunus Villa, painted for the comments of master Shouqiao. In the second month of summer [the fifth month] in the *jisi* year [1809], [signed] Bushi Chen Qian, [artist's seals] Chen, Qian.

Chen's scratchy brushwork gives an unkempt look to the villa and its surrounding marshland, and despite discrepancies of scale, he has presented a convincing spatial setting for this lowland wilderness. Though little is recorded of Chen's life, he was apparently a contemporary of Jiang Hao and a collaborator with him on other works (see *ZMRC*, 1016).

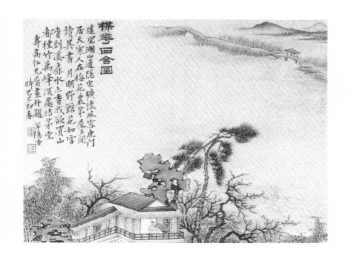

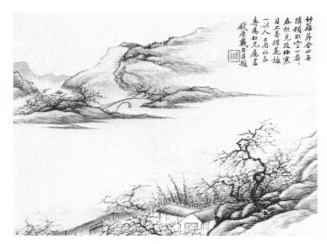

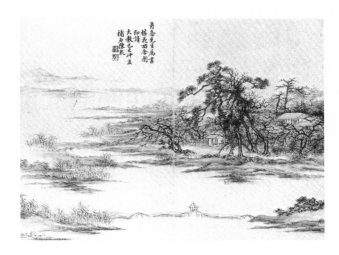

Leaf E

Painted in ink and color by Zhou Li (1736-1820), and inscribed by the artist:

> Picture of the Prunus Villa, painted for the comments of master Shouqiao, in the eight month of the *jisi* year [1809]. [Signed] Wuzhong Zhou Li, [artist's seal] Yunyan.

This leaf takes a far more intimate view of the cottage, perhaps because Zhou Li's expertise lay in figure and flower subjects rather than landscapes. The composition, closed in by mists and cliffs at the top, brings to mind one of Zhou Li's figure paintings, a hanging scroll dated 1804 in the Hashimoto collection (Suzuki, JP30-070).

Leaf F

By Tao Guan (1794-1849), painted in ink and light color and inscribed by the artist:

> Picture of the Prunus Villa, painted for the comments of master Shouqiao, in the fifth month, summer of the *jisi* year [1809]. [Signed] Tianmei Jushi Tao Guan, [artist's seal] Tao Guan.

Like Zhou Li, Tao Guan was not noted as a landscape painter but rather for flowers and even plum blossoms, a theme in which he followed Jin Nong (see Suzuki JM1-176-7 through JM1-176-12). Tao would have been only a teenager when he painted this leaf for Shouqiao, a fact which may account for its tentative brushwork and weak drawing.

Leaf G

By an unidentified artist, this leaf is in ink only:

> The Prunus Villa, painted for the comments of master Shouqiao in the early summer of the *jisi* year [1809]. [Signed] Oufang, [artist's seals] Ou, Fang. [one additional seal, unidentified]

Leaf H

In ink and light color, this leaf returns to the panorama, with an almost naive approach to architecture and figures. The artist, Xu Huawen, inscribed a poem:

> I have a plot of land west of the river which
> measures several *gong*.
> A small thatched cottage leans in the east wind.
> Spring is forever present.
> Blossoms of ten thousand prunus send their
> congratulations.

> In the spring of the *jisi* year [1809], visiting the Yiyu Thatched Studio from Yingdou Lake. At master Shouqiao's request I paint the Prunus Villa on a blank album leaf on his fiftieth birthday and also inscribe a poem. [Signed] Buluo Xu Wen, [artist's seal] Wen.
>
> [translations by Wai-fong Anita Siu]

Xu was a student of Xi Gang (see *ZMRC*, 941), but his painting here seems to reflect not that orthodox master's style but the local tradition as seen in the other leaves of the album.

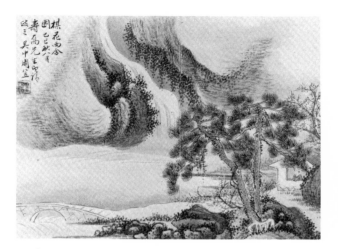

Leaf E

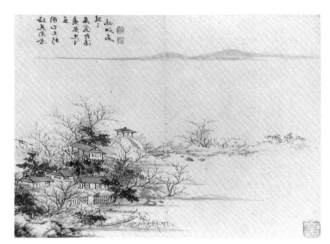

Leaf G

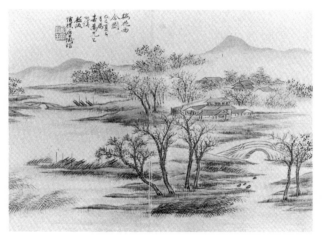

Leaf F

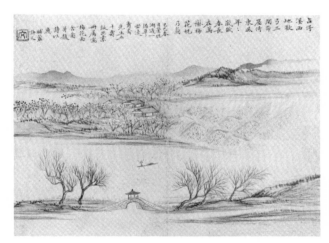

Leaf H

41 DAI XI (1801-60)

Landscape

Dated 1837
Hanging scroll, ink and color on paper
61.9 × 37.9 cm

A native of Qiantang (Hangzhou), Dai Xi was born into a scholar-gentry family whose wealth from the salt trade gave them a privileged social rank. His literary interests developed in his early years, and after receiving the *jinshi* degree in 1832 he embarked upon a successful official career, which included appointment to the Hanlin Academy, and posts as Vice-President of the Board of Rites and Sub-chancellor of the Grand Secretariat. During the Taiping Rebellion, he led the imperial defense and helped train the army in Hangzhou. In 1860, when the city fell to the rebels, Dai Xi composed his last poem and committed suicide.

Dai Xi's painting derives from the Orthodox tradition, and generally is seen to embody the spirit and style of his principal model, Wang Hui. This is exemplified in the overall compositions of his large hanging scrolls. Nonetheless, his forceful brush-work may be indebted to the Zhe School, while his poetic mood in intimate album leaves can be traced back to Song models.

His personal innovation, the 'cicada's coat textural stroke' *(shan yi cun)*, was characterized by a light ink outline filled with dry modelling strokes. Employing dry ink to highlight moss dots over the peaks, he achieved a tonal balance between richness of ink and dryness of brushwork that was one of the essential qualities of his sober landscapes. In a text entitled *Comments on Painting from the 'Accustomed to Bitterness Studio' (Xikuzhai Hua Xu)*, he emphasized the idea of *xie sheng*, or painting from nature, affirming the importance of the artist's perception of and direct interaction with natural scenery:

> Rising up early in the morning, looking up at the sky and across to mountain ranges, I am
> at one with the clouds and mist. Afraid of losing them, I pick up the brush and depict them.

Dai Xi dedicated this small landscape to his cousin:

> In the twelfth month of the *dingyou* year [1837], imitating the brush of Huanghe Shanqiao
> [Wang Meng], presented to elder master Shutian, [signed] Chunshi, younger cousin Dai
> Xi, [artist's seal] Luchuang shi hua.

The painting was formerly in the Dai Tong Xuan collection.

Published: *Jinshijia Shuhua Ji*, first *ji*, 229.

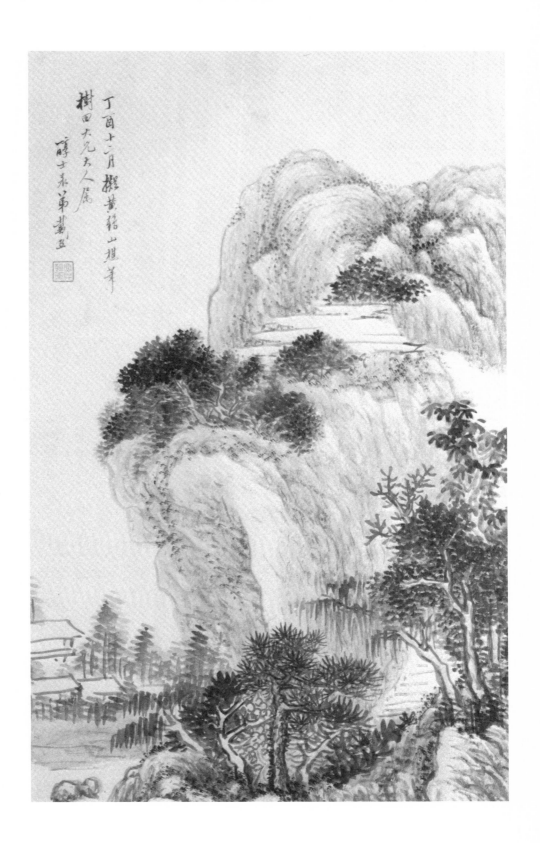

丁酉十二月擬黄鶴山樵筆
樹田大兄大人屬
醇士弟蔚畫

42 QIN BINGWEN (1803-73)

Landscape in the Manner of Wang Shimin

Dated 1861

Hanging scroll, ink on paper

123 × 36 cm

A native of Wuxi, on the shores of Lake Tai, Qin Bing-
wen received his *juren* degree in 1840, and served as a
minor official. A noted collector and connoisseur, his
large body of recorded works (listed in the catalogue
compiled by his grandson Qin Qian: *Pu Hua Ji Yu*, 1929)
includes landscapes following Wang Jian and Wang
Shimin, as well as Huang Gongwang, Shen Zhou and
other models favored by Orthodox painters. Here the
monumental composition and powerfully modelled
land masses recall Wang Shimin, but the dynamic
interplay of planes within the landscape and the soft,
rubbed quality of the ink have their source in the work
of Wang Yuanqi and his followers. The artist inscribed:

> I imitate the method of Xilu Laoren [Wang Shimin] and
> present it for the comments of senior Yanyi [uniden-
> tified] in the *qinghe* month [the fourth month] of
> the *xinyou* year [1861]. [Signed] Liangxi Qin Bingwen,
> [artist's seals] Yiting Shuhua, Qin Bingwen Yinxin,
> Leci Bupi.
>
> [translation by Wai-fong Anita Siu]

With this landscape and that of Zhang Xiong [43],
we see the transformation of the Four Wang into re-
vered ancient masters worthy of acknowledged emu-
lation. These founders of the Orthodox School had
already exerted tremendous influence on the Four
Lesser Wang and others in the late eighteenth and early
nineteenth centuries, but only now did they come to
be cited explicitly as stylistic models, alongside such
Song and Yuan masters as Mi Fu and Ni Zan.

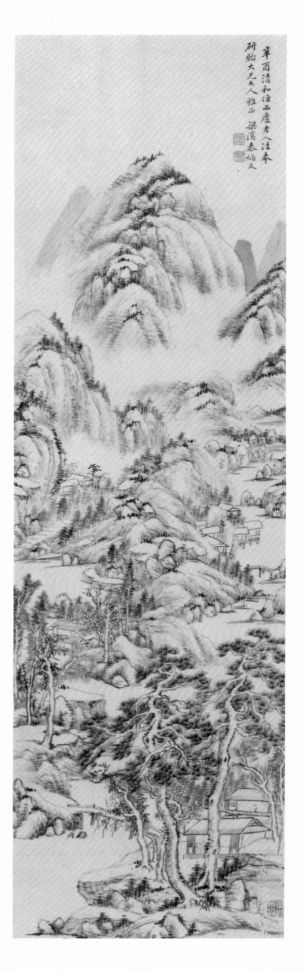

43 ZHANG XIONG (1803-86)

Landscape in the Manner of Wang Jian

Dated 1886
Hanging scroll, ink and color on paper
173.2 × 47 cm

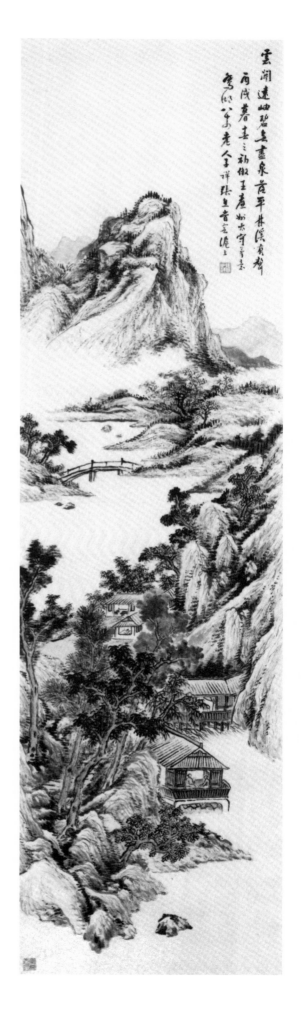

Noted particularly for his flower paintings, Zhang Xiong was a native of Jiaxing, Zhejiang province. He also painted figure subjects and landscapes, carved seals and collected antiquities. The present work is similar in style to two other hanging scrolls painted during Zhang's eighties, a landscape in the Matsumaru collection, dated 1883 (Suzuki, JP67-080), and another in the Kyoto National Museum, dated 1884 (JM11-066). This cluster of works suggests Zhang's particular interest in the Orthodox manner of landscape painting.

Painted in Zhang's last year of life, this hanging scroll is inscribed:

> Beyond the clouds stand distant mountains in endless verdant growth.
> In the plain a brook trickles, its rippling heard through the grove.

Imitating the style of Prefect Wang Lianzhou [Wang Jian], in the early days of late spring of the *bingshu* year [1886]. Painted by Zixiang Zhang Xiong of Lake Yuan in his eighties, at the time of a visit to Hu [Shanghai], [artist's seal] Zhang Zixiang.

[translation by Jane Wai-yee Leong]

44 LU HUI (1851-1920)

Figure Paintings after Old Masters

Album of 10 leaves, ink and color on silk
Each leaf 28 × 35.8 cm

Lu Hui was a native of Wujiang district in Jiangsu province, but spent much of his later life in Suzhou (see *Modern Spirit*, 37, and Ellsworth, I, 111-112). As friend and advisor to the scholar-official and poet-painter-collector Wu Dazheng (1835-1902), Lu would have had access to many old paintings. He is best known for landscapes and flower-and-bird compositions featuring broad strokes of color and ink.

Here in an uncharacteristically meticulous technique, Lu recreates the figure styles of ten great painters of the past, ranging from Dai Song in the eighth century to Ming and Qing masters like Chen Hongshou (1599-1652) and Yu Zhiding (1647 - circa 1705). Specific models for Lu's compositions have not been identified. Apart from leaves A and B, whose inscriptions refer to specific paintings by Dai Song and Liu Songnian (active late twelfth – early thirteenth century), most of these compositions appear to have been freely invented by Lu in keeping with characteristic themes and techniques of earlier masters.

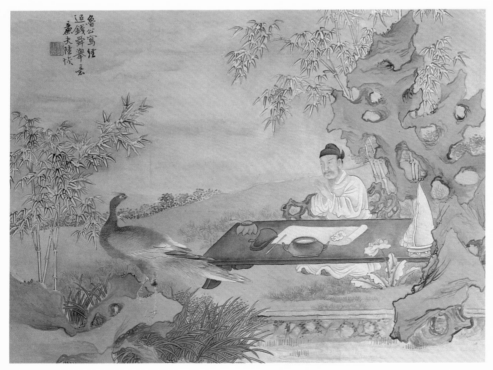

Leaf C

Leaf A

Pasturing in the Wilds. Having seen the long handscroll *One Hundred Buffalo* by Dai Song, [I] excerpted this and embellished it with trees and rocks. [Signed] Lianfu Hui, [artist's seal] Lianfu.

Leaf B

The Four Greybeards of Mount Shang. I fall wide of the original by Liu Songnian. [Signed] imitation by Lu Hui, [artist's seal] Lianfu.

Leaf C

Lu Gong [Yan Zhenqing] Writing a Sutra, following the idea of Qian Xuan. [Signed] Lianfu Lu Hui, [artist's seal] Lu Hui zhi yin.

Leaf D

The Hermit's Lesson, stemming from Zhao Songxue [Zhao Mengfu]. [Signed] Lu Hui, [artist's seal] Lianfu.

Leaf E

Picture of a literary gathering, following the idea of Tang Liuru [Tang Yin]. [Signed] Hui, [artist's seal] Lianfu.

Leaf F

The Garden of Solitary Pleasure, stemming from Qiu Shifu [Qiu Ying]. [Signed] Lu Hui, [artist's seal] Lianfu.

Leaf G

Portrait of Guan Furen [Guan Daosheng], following the idea of Ding Nanyu [Ding Yunpeng]. [Signed] Hui, [artist's seal] Wujiang Lu Hui.

Leaf H

Scholars and Plum Blossoms, stemming from Laolian Zhushi [Chen Hongshou]. [Signed] Lianfu, [artist's seal] Lianfu.

Leaf I

Sketched in brilliant colors, in harmony with Chen Xiaolian [Chen Zi]. [Artist's seal] Wujiang Lu Hui.

Leaf J

Appreciating the Springtime in Jin Gu Garden, following the great narrator Yu [Yu Zhiding]. [Signed] Lianfu, [artist's seal] Lu Hui zhi yin.

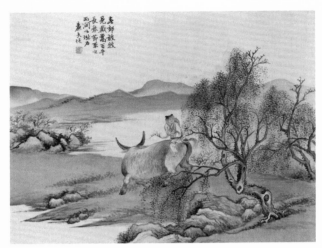

Leaf A

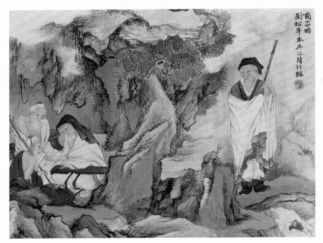

Leaf B

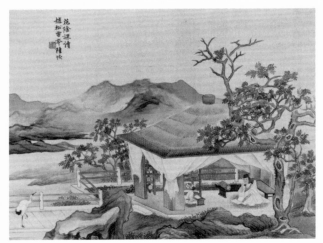

Leaf D

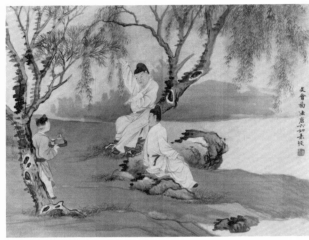

Leaf E

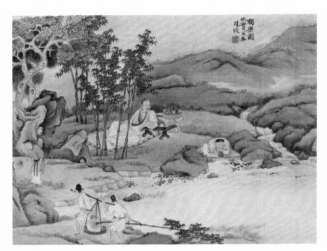

Leaf F

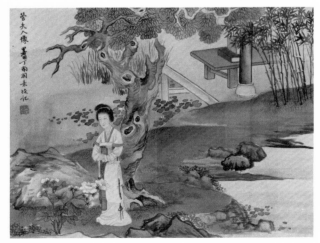

Leaf G

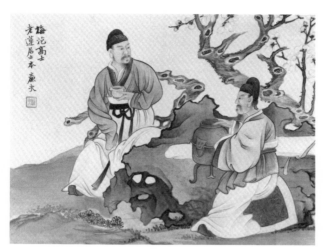

Leaf H

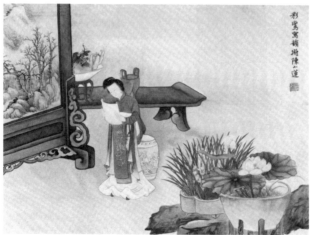

Leaf I

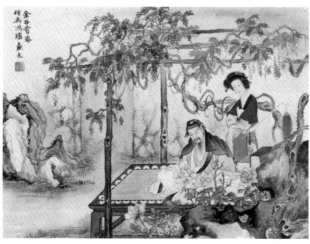

Leaf J

Abbreviations:

ECCP Hummel, Arthur W. *Eminent Chinese of the Ch'ing Period*. Washington DC, 1943.

ZGSHT *Zhongguo Gudai Shuhua Tumu*, vol. 1. Compiled by the Authentication Group for Ancient Works of Chinese Painting and Calligraphy. Beijing, 1986.

ZMRC Yu Jianhua and others. *Zhonguo Meishujia Renming Cidian*. Shanghai, 1981.

Bibliography of Works Cited in the Catalog

Cahill, James. 'Yuan Jiang and his School,' *Ars Orientalis* 5 (1963): 259-72, and 6 (1967): 191-212.

———. 'The Early Styles of Kung Hsien,' *Oriental Art* 16 (1970): 51-71.

———. *The Distant Mountains: Chinese Painting of the Late Ming Dynasty, 1570-1644.* New York and Tokyo, 1982.

———. *The Compelling Image: Nature and Style in Seventeenth-Century Chinese Painting.* Cambridge, 1982.

———, ed. *The Restless Landscape: Chinese Painting of the Late Ming Period.* Exhibition catalog. Berkeley: University Art Museum, 1971.

———, ed. *Shadows of Mt. Huang: Chinese Painting and Printing of the Anhui School.* Exhibition catalog. Berkeley: University Art Museum, 1981.

Chūgoku no Kaiga: Hashimoto Korekushon, Min Shin Kindai. Exhibition catalog. Tokyo: Shibuya Kuritsu Matsunami Bijutsukan, 1984.

Dai Xi. *Xikuzhai Hua Xu.* Taipei, 1972 reprint.

Ecke, Tseng Yu-ho. *Poetry on the Wind: The Art of Chinese Folding Fans from the Ming and Ch'ing Dynasties.* Exhibition catalog. Honolulu Academy of Arts, 1982.

———. *Wen-jen Hua: Chinese Literati Painting from the Collection of Mr. and Mrs. Mitchell Hutchinson.* Exhibition catalog. Honolulu Academy of Arts, 1988.

Eight Dynasties of Chinese Painting: The Collections of the Nelson Gallery-Atkins Museum, Kansas City, and The Cleveland Museum of Art. Exhibition catalog. Cleveland, 1980.

The Elegant Brush: Chinese Under the Qianlong Emperor, 1735-1795. Exhibition catalog. Phoenix Art Museum, 1985.

Ellsworth, Robert H. *Later Chinese Painting and Calligraphy, 1800-1950.* 3 vols. New York, 1986.

Ferguson, John C. *Lidai Zhulu Hua Mu.* Nanjing, 1934.

Fu Shen and Marilyn Fu. *Studies in Connoisseurship: Chinese Paintings from the Arthur M. Sackler Collection in New York and Princeton.* Exhibition catalog. Princeton: The Art Museum. 1973.

Ge Jinlang. *Airiyinlou Shu Hua Lu.* Taipei, 1977 reprint.

Gugong Shuhua Lu. Rev. ed. 4 vols. Taipei, National Palace Museum, 1965.

Guo Weiqu. *Song Yuan Ming Qing Shuhuajia Nianbiao.* 2nd edition. Beijing, 1982.

Harada Bizan. *Nihon Genzai Shina Meiga Mokuroku.* Tokyo, 1938.

Hearn, Maxwell. 'Document and Portrait: The Southern Inspection Tour Paintings of Kangxi and Qianlong,' *Phoebus* 6 (1988): 91-131.

Hu Jitang. *Bixiaoxuan Shu Hua Lu* (preface dated 1839).

Images of the Mind: Selections from the Edward L. Elliott Family and John B. Elliott Collections of Chinese Calligraphy and Painting at the Art Museum, Princeton University. Exhibition catalog. Princeton: The Art Museum. 1984.

Jiang Baoling. *Molin Jinhua.* Preface dated 1851 (Taipei, 1975 reprint).

Jinshijia Shuhua Ji. 2 vols. Tokyo, 1977 reprint.

Kohara Hironobu, ed. *Tō Kishō no Shoga.* Tokyo, 1981.

Laing, Ellen Johnston. 'Biographical Notes on Three Seventeenth Century Chinese Painters,' *Renditions* 6 (Spring, 1976): 107-08.

Li, Chu-tsing. *A Thousand Peaks and Myriad Ravines: Chinese Paintings in the Charles A. Drenowatz Collection.* 2 vols. Ascona, 1974.

Li Dou. *Yangzhou Huafang Lu*. Taipei, 1969 reprint.

The Modern Spirit in Chinese Painting: Selections from the Jeannette Shambaugh Elliott Collection. Exhibition catalog. Phoenix Art Museum, 1985.

Moss, Paul. *The Literati Mode: Chinese Scholar Paintings, Calligraphy and Desk Objects.* Exhibition catalog. London, 1986.

Mu Yiqin. *Mingdai Yuanti Zhepai Shiliao*. Shanghai, 1985.

Nie Chongzheng. *Yuan Jiang yu Yuan Yao*. Shanghai, 1982.

Ninety Years of Wu School Painting. Exhibition catalog. Taipei: National Palace Museum, 1975.

Paintings by Yangzhou Artists of the Qing Dynasty from the Palace Museum. Exhibition catalog. The Art Gallery, Chinese University of Hong Kong, 1984.

Paintings of the Ming and Qing Dynasties from the Guangzhou Art Gallery. Exhibition catalog. The Art Gallery, Chinese University of Hong Kong, 1986.

Qian Zhuchu Shanshui Jingpin. Shanghai, 1926.

Shina Meigashū. Tokyo, 1922.

Shiqu Baoji. Zhang Zhao and others, eds. 1745 (Taipei, 1971 reprint).

Shiqu Baoji Xubian. Wang Jie and others, eds. 1793 (Taipei, 1971 reprint).

Silbergeld, Jerome. 'Kung Hsien: A Professional Chinese Artist and his Patronage,' *Burlington Magazine* 123 (1981): 400-10.

Sirén, Osvald. *Chinese Painting: Leading Masters and Principles*. London and New York, 1956-58.

Style Transformed: A Special Exhibition of Works by Five Late Ming Artists. Exhibition catalog. Taipei: National Palace Museum, 1977.

Suzuki Kei et al. *Comprehensive Illustrated Catalog of Chinese Paintings*. 5 vols. Tokyo, 1982-3.

Tuhui Baojian Xuzhuan (*Huashi Congshu* edition. Yu Anlan, ed. Beijing, 1962).

Wang Hui Hua Lu. Exhibition catalog. Taipei: National Palace Museum, 1970.

Views from Jade Terrace: Chinese Women Artists, 1300-1912. Exhibition catalog. Indianapolis Museum of Art and New York: Rizzoli. 1988.

Wilson, Marc. *Kung Hsien: Theorist and Technician in Painting*, Nelson Gallery and Atkins Museum *Bulletin* 4: no. 9 (1969).

Wu, William. 'Kung Hsien's Style and his Sketchbooks,' *Oriental Art* 16 (1970): 72-81.

Xu Bangda. *Zhongguo Huihuashi Tulu*. 2 vols. Shanghai, 1981-84.

Yang Boda. 'Leng Mei ji qi *Bishu Shanzhuang Tu*,' in *Gugong Bowuyuan Cang Bao Lu*, Hong Kong and Shanghai, 1985, 172-77.

Yu Jianhua, ed. *Zhongguo Hualun Leibian*. Peking, 1957.

Zhang Geng. *Guochao Huazheng Lu* (*Huashi Congshu* edition. Yu Anlan, ed. Beijing, 1962).

Zhongguo Lidai Shuhua Zhuankejia Zihao Suoyin. Shang Chengzuo, ed. Beijing, 1960.